Make your own
Books & Boxes

Make your own
Books & Boxes

Peter Baumgartner

SEARCH PRESS

First published in the UK 1996
by Search Press Limited
Wellwood, North Farm Road,
Tunbridge Wells, Kent TN2 3DR

Originally published in German 1994
by Falken-Verlag GmbH,
65527 Niedernhausen/Ts.,
under the title of *Bücher, Alben, Schachteln selbermachen.*
Copyright © Falken Verlag 1994

English translation © Search Press Ltd. 1996
Translated by Clare Turner

Cover design: Bayerl & Ost GmbH, Frankfurt am Main.
Editor: Christiane Rückel
Production and design: Petra Zimmer
Photographs: Photo-Illustrations Ltd., Jersey
Drawings: Daniela Schneider, Frankfurt am Main
Picture sources: page 10 (top) and page 11 (top)
HISTORIA PHOTO, Ingrid Reck-Fremke, Hamburg;
pages 6-9, pages 10 (bottom) and page 11 (bottom),
Archiv für Kunst und Geschichte, Berlin.

ISBN 0 85532 812 6

Printed in Malaysia by Times Offset.

Contents

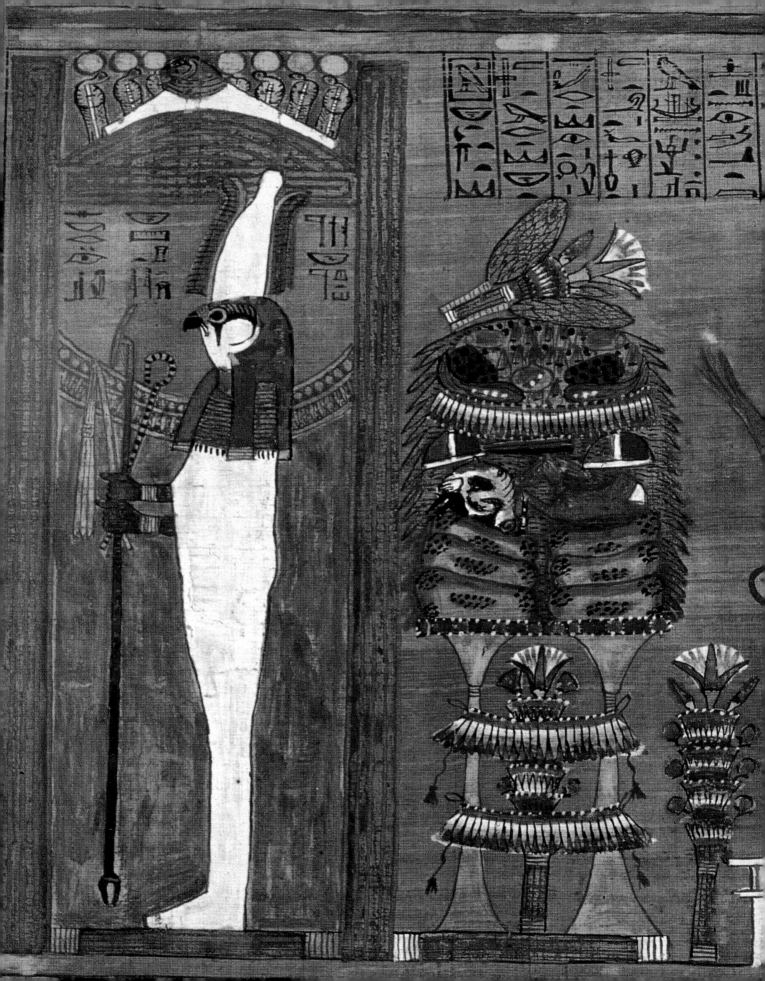

From papyrus to the paperback

Books have a history, and it reads like a thrilling novel! On the following pages, read about the burning of the library in Alexandria, mediaeval monasteries, and the invention of printing.

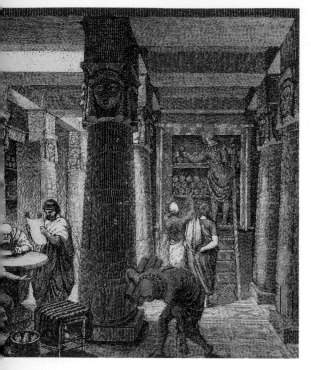

lengthwise on a board dampened with water from the Nile. The layers are completed by laying on more strips crosswise. Now the whole thing is placed under a press and dried in the sun.'

During the pressing process, a starchy sap was released which bound the strips of papyrus into firm, elastic sheets. Once dried, up to forty sheets were stuck together to make rolls and used for all kinds of writing (first the inside of the roll was written on, then the outside).

The most comprehensive library of the day was in Alexandria, an ancient city on the Nile delta. When the city was conquered in 48 BC by Caesar's troops, the famous library was razed to the ground – with it, 700,000 papyrus rolls were burnt, and much of the knowledge of that time was lost forever.

In Asia Minor, parchment had been used to write on since the second century BC. The word comes form the Latin *charta pergamena* (paper from Pergamon), and the town of Pergamon had a vast library containing over 200,000 parchment rolls of material written in the first century BC. These

The library of the ancient city of Alexandria had the greatest collection of papyrus rolls known at the time. They were burned when Caesar's troops conquered the city.

The history of the book

Rolls and sheets

Five thousand years ago the Egyptians were already making a writing material similar to paper in sheet form – papyrus. The plant originally grew only in Egypt, and the export of papyrus was a royal monopoly. Only much later on did the Romans plant papyrus in Sicily. Pliny the Elder (AD 23/24–79), a Roman historian, describes in his famous *Naturalis historis* ('Natural history') the production of papyrus.

'The papyrus grows in marshy places. Paper is produced from it by cutting the stem into very thick strips with a knife, keeping them as wide as possible. Next, the strips are laid close to one another

rolls were much better for writing on than papyrus, and also lasted longer, so parchment gradually began to replace it in the fourth and fifth centuries BC. The production technique (it was made by carefully cleaning animal skins of all hair, bits of flesh, and fat, placing them in lime, stretching and scraping them, and rubbing them with pumice stone) spread via Rome to Europe.

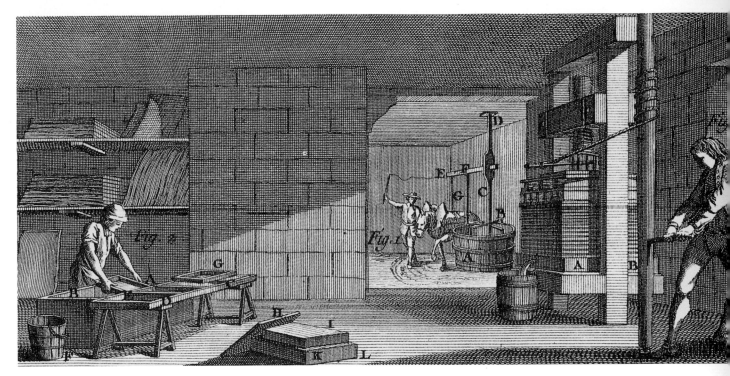

A view of an eighteenth-century paper workshop. On the left, paper fibres are being deposited on the mesh and on the right, paper is being pressed. In the background you can see a paper mill (see also the illustration below). Copper engraving by Benard.

The normal book format with a number of single pages lying one on top of another, was developed around the time of the birth of Christ. Papyrus and parchment rolls were a bother to read, and having turnable pages made things much easier. By 300 AD the book format had arrived in Europe.

Mediaeval books

After the fall of the Roman Empire, monasteries were established all over Europe. These contained *scriptoria* in which monks copied the Bible and the writings of authors of antiquity and illuminated them beautifully.

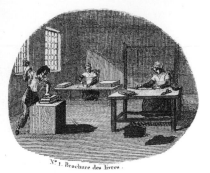

1. Sewing the bookblock.

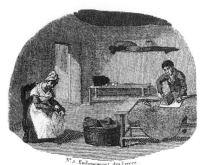

2. Casing-in

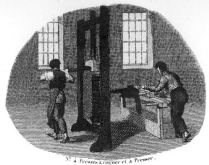

3. Pressing.

The monks also bound the books by folding each sheet of parchment in half, putting them together into sections, and sewing them with needle and thread on to hemp ties. They pulled these ties through holes in wooden covers and fastened them to it. In this way, the bookblock – the sheets of parchment – and the wooden cover were tightly bound together. Simple everyday books were covered with leather and provided with metal corners. On the covers of special decorative volumes, goldsmiths applied reliefs in ivory, chased silver and gold, jewels, pearls and enamel.

In the Middle Ages, making books was very labour-intensive because they were written by hand on parchment and, therefore, they were very expensive. For example, the Countess of Amjor commissioned a book from a monastery, for which she had to pay the monks two hundred sheep, three tonnes of grain and a number of sable furs.

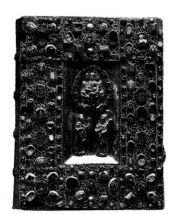

Cover of the Samuel-Evangeliar, from the treasures of Quedlinburg cathedral (1225–1230).

The invention of printing

In 105AD paper was being produced in China, but it was not until a thousand years later that the art of paper-making reached Europe, via the Far East and North Africa. The first paper-mill in Germany was erected in 1390 by Ulman Stromer.

Through the use of paper and the invention of printing, book production took less time and was considerably cheaper. Printing with loose type was invented by Johannes Gutenberg, who worked in Strasbourg and Mainz. In 1455 he printed the famous Gutenberg Bible with a print run of 180 copies. Forty-eight of these precious books still exist today.

Thanks to Gutenberg's invention, book production began to develop very quickly. Around 1500AD, 'modern' printing was only about fifty years old, but in Germany alone there were already 300 printing works. The monastery bookbinders were supplanted more and more by craftsmen, who united under the bookbinders' guild. The massive wooden book covers disappeared and were replaced by cardboard ones, which made these books look finer and more elegant. The expensive and labour-intensive bindings such as leather and parchment

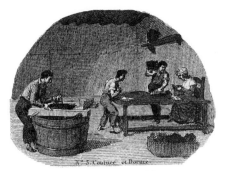

4. *Painting and gilding.*

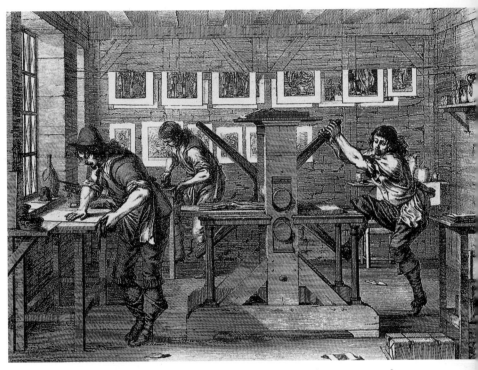

Above: Inside a seventeenth-
century French book-printer's.

gave way to more and more paper. The covers of these tore relatively easily, so at the beginning of the nineteenth century linen binding was brought in.

Industrial book production

The next important stage in the history of book production was the nineteenth-century industrial revolution, which made mass production possible. Then, in 1937, perfect binding was introduced - a method of gluing single sheets of paper rather than sewing folded sheets. This technique made it possible to produce what we now know as paperbacks.

However, not all modern books are mass-produced. Some libraries, collectors and booklovers still have their books bound by a craftsman. These craftsmen hardly ever use machines and thus they carry on a centuries-old tradition, as indeed will anyone who uses the techniques shown in this book.

Johannes Gutenberg spent twenty years developing typesetting and printing with hot-metal moveable type. The illustration on the left shows Gutenberg during his time in Strasbourg (1434–1444).

All the basics

This introductory chapter tells you all about the tools you will need, the materials used, and important basic techniques such as measuring, cutting and gluing.

What is paper?

Paper is a flat material made from plant fibres, water and various additives.

Until the eighteenth century the raw material for paper-making was textile-based. Rag-and-bone men collected old clothes and discarded fabrics which were then torn into small pieces and pounded in water until they were reduced to pulp.

In the nineteenth and twentieth centuries, wood was used more and more to make paper. With the help of acids or lye, huge machines reduced tree trunks into microscopic fibres, which are then mixed with water and sieved. Once the water has drained, a wet, porridgy mass remains, the fibres of which are matted together. After several pressings the paper is finished. In the past, every sheet of paper was individually created by hand; today machines shoot out an endless stream of paper 10m (30ft) wide at speeds of 120 kilometres per hour (75mph).

There are many types of paper: cotton fibre or wood free (containing cellulose); paper made from wood pulp and recycled paper. Paper is made in rolls or flat sheets of various sizes for a multitude of uses from printing and writing to packaging.

Weight

An important way of distinguishing between papers is by its weight. Paper weight is commonly measured in gsm units (grams per square metre) or in pounds (lb). The typical weight of a standard writing paper is 90gsm (60lb), and a good weight for a large scrap book would be 260gsm (120lb).

If a 'paper' weighs more than about 160gsm (90lb) it is generally referred to as board. Thicker boards can also be measured by their thickness (caliper).

From top to bottom: millboard, cardboard, kraft wrapping paper, corrugated paper, greyboard.

Grain

Another important feature is the grain of a paper.

Machine-made paper is produced as a continuous web which is then wound as a very large reel of paper. The speed of production causes all the fibres to lie parallel to each other along the length of the reel to form the grain of the paper.

The reels of paper are later cut up into smaller sheets, lengthwise (parallel to the edge of the reel) and widthwise (at right angles to the edge of the reel). Depending on how the sheet is cut, its fibres will run either from top to bottom (lengthwise) or from left to right (widthwise). The former is referred to as long grain (**1**) and the latter as short grain (**2**).

So how can you tell which way the grain runs in a sheet of paper?

▶ If you dampen one side of a sheet of paper, it will always curl in the opposite direction to the grain.

▶ A sheet of paper is easier to fold along the grain than across it.

▶ Paper is easier to tear with the grain than against it.

Before you work with paper, you should always establish the grain direction, or you may have problems later. In bookbinding, for example, the grain of all the sheets of paper, including the materials used for the cover, should run in the same direction – preferably from head to tail (parallel to the spine of the book).

After gluing a piece of paper, let the glue soak in for a few minutes before sticking it down, because the paper will expand against the grain.

Sheet sizes

Most of the papers are produced in standard sheet sizes.

In the metric system of paper sizes the most common format is the A series. A0 is the largest sheet and measures 841 x 1189mm (a surface area of $1m^2$). The ratio of short side to the long side is such that when an A0 sheet is folded in half lengthwise, the resultant rectangles (called A1) are in proportion to the original sheet. Halve these sheets again to obtain A2 size sheets, etc. The table below gives the measurements of all the sheet sizes in the A series. A4 is the most widely used size for writing paper.

1. *Long grain.*

2. *Short grain.*

Metric system A series	
Ref	Sheet size
A0	841 x 1189mm
A1	594 x 841mm
A2	420 x 594mm
A3	297 x 420mm
A4	210 x 297mm
A5	148 x 210mm
A6	105 x 148mm
A7	74 x 105mm

In other systems the sheet sizes vary with particular types of paper. Bond (writing) paper, for example, has a basic sheet size of 17 x 22in which when cut into four produces a standard sheet size of $8^{1}/_{2}$ x 11in. Other basic sizes in 25 x 38in (coated, text, book and offset papers), 24 x 36in (newsprint) and 20 x 26in (cover papers/boards).

Materials & tools

Most of the materials and tools that you will need for making books, albums and boxes shown in this book are available from art and craft shops. Some you may have to buy from a bookbinder's supplier.

A professional bookbinder may often use an expensive special machine, while hobby bookbinders can make do with tools they already have at home, or that can be bought cheaply.

For the inside of the notebooks and books – the bookblock – the best thing to use is wood-free white offset paper with a weight of 100gsm (70lb) and a short grain (see page 15). You can also use re-cycled paper if you like.

Ingres paper

A slightly textured coloured paper, used for endpapers and as the basic paper for making your own decorative papers (see page 22 onwards).

Card

Thin card, or a heavyweight cartridge paper, is ideal for making the bookblock for scrapbooks and photograph albums. 50 x 70cm (20 x 26in) sheets are the best size from which to cut the individual leaves of the album.

Do experiment with different colours of card, and try to match the colour to that of the cover materials.

Decorative and textured paper

There is a very wide range of decorative and textured papers that you can use on cover boards. You can also make your decorative papers (see pages 23–32).

Elephant hide (see below, third, sixth and eighth from the left) is just one type of textured paper that you can use on book covers. Textured paper is available in a wide range of colours from craft shops and stationers.

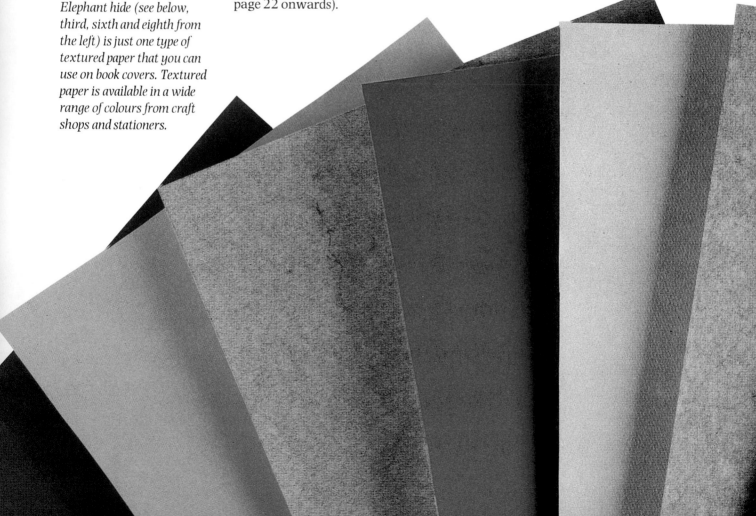

Kraft wrapping paper

This is very good for strengthening but should not be visible on the finished book.

Millboard

This is the best type of board for the covers of books, albums and portfolios. It is a high-density fibre board and is available in a number of different thicknesses. It should be at least 1.5mm ($^1/_{16}$in) thick.

Greyboard

This is less dense than millboard and is very easy to cut; an excellent material for making boxes. The board should be 2mm ($^1/_{16}$in) thick. Because its fibres absorb liquid well, it is also suitable for use as a 'blotting pad' for drying books.

Scrap paper

Before gluing a whole surface, cover your table with scrap paper to protect the surface. Throw it away after use.

Bookcloth

A book can also be covered with this special fabric, either all over or only on the spine. Normal fabric is no good for this because the glue that is applied to the reverse of the fabric comes through and leaves marks on the front. Book cloth is, therefore, lined with a thin layer of paper or treated with a dressing which stops this happening. Fabric, like paper, also has a grain (see page 15). The lengthwise threads are known as the warp and the horizontal ones, the weft (or woof), are woven into them. You should always cut fabric lengthwise, so that the cut edge runs parallel to the warp.

Mull and calico

Mull is an open-weave muslin or scrim used to stabilise glued areas such as the spine. When the book is finished, it is no

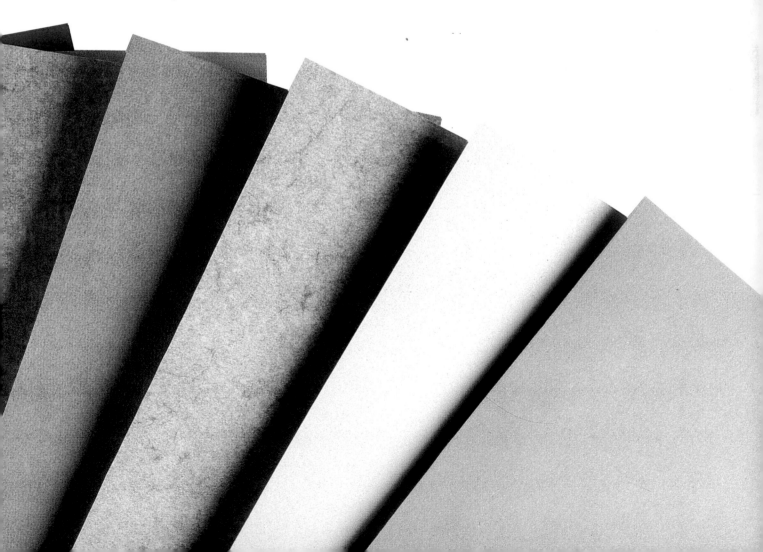

Bookmark ribbons.

longer visible. Calico is a lightly woven white or grey fabric which can be used for the same purpose. You should cut mull and calico lengthwise as described on page 17.

Pressing boards
You should use plastic-coated plywood boards. You will need two boards 175 x 250mm (7 x 10in) and two 250 x 350mm (10 x 14in). They should be at least 20mm ($^3/_4$in) thick.

Sewing thread
As a general rule, sewing thread must be strong enough to support the paper but not so thick that it will cause swelling in the spine. Waxed thread is best, and is available from book-binding suppliers,

Sewing thread.

Headband.
This is a coloured ribbon, usually 5mm ($^1/_4$in) wide, which is attached to the bookblock at the head and tail. Buy a selection of colours, so that you always have a suitable one in stock.

Glue
The professionals use bone glue and paste. For the home bookbinder, PVA (polyvinyl acetate) is the best adhesive. It can be diluted with water, but is water-proof when it dries, so remember to wash any splashes of glue off your clothes im-mediately. When buying glue, make sure you can also use it for glued bind-ings. Wood glue, which looks similar to bookbinders' glue, is not suitable.

Scissors
You will need a pair of sturdy scissors about 150–200mm (6–8in) long for freehand cutting. If the blades stick to-gether because they have got glue on them, scrape off the glue with an old kitchen knife and some hot water.

Guillotine
For cutting board, a small guillotine will be excellent. You can cut board up to 1.5mm ($^1/_{16}$in) thick with it.

Craft Knife
Use a craft knife to cut thicker board, and cut along a steel straight-edge.

Bookbinders' Knife
A flat-bladed knife used for slicing folded sheets of paper – much better than a craft knife, but you could use a sharp kitchen knife with a 50–100mm (2–4in) blade.

Steel straight-edge.
To help you cut straight lines and precise corners, get two steel straight-edges of different lengths, one 300mm (12in) long and one 600mm (24in). A steel T-square is also useful. Wooden or plastic rulers are not suitable for cutting along.

Cutting mat.
A self-healing mat is best for cutting on. You could use thick card, but after a while making precise cuts will get to be impossible.

Bone folder.
This special bookbinders' tool is used for all sorts of things. It is a small knife-shaped tool made of animal bone used for creasing folds in paper.

Ruler.
For measuring, you will need a ruler at least 400mm (16in) long. The folding type of ruler, where the scale markings start right at the end, is best.

Steel straight-edge.

Scissors.

Brushes

You will need at least two different sizes of brushes: one small round or flat brush about 15mm (¹/₂in) wide and a larger flat brush about 50mm (2in) wide. It is worth buying good-quality brushes, because the bristles start falling out of the cheap ones very quickly. Clean the brushes after use under running water with some soap.

G-clamp.

For pressing, you will need two G-clamps at least 200mm (8in) long.

Weights.

You can use metal blocks covered with paper. Weights from old scales, or flat-irons are suitable.

Darning Needle.

For stitching thin sections of paper, use a 60mm (2¹/₄in) long darning needle.

Awl.

When you are stitching thicker sections bore the holes with an awl first.

Pencil.

For marking, use a soft pencil – never use a ballpoint or felt-tipped pen.

Rubber hammer

Finally, if you already have some experience in bookbinding, you will appreciate a rubber hammer to finish off your hand-made book.

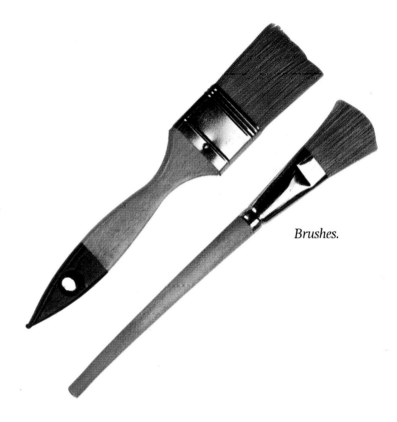

Brushes.

Headband ribbons.

Basic techniques

Whether you are making books, albums, portfolios or boxes, the same techniques are used: measuring, cutting, gluing and pressing.

If you do not want to use a craft knife, when you have measured your lines, mark them with fine pencil lines and then cut along these with scissors. Scissors are also used when you are only cutting short lengths of paper or cloth.

Measuring

Before cutting paper to size, you will have to measure it. It is very important to ensure that your measurements are exact and square at the corners.

To protect the table you are working on, cover it with a cutting mat. Place the piece of paper on the cutting mat and align your ruler with its top edge. Slide the ruler along until the scale marking for the width of paper is on the right-hand edge of the paper (**1**).

Now place a straight-edge with its bevelled edge against the left-hand end of the ruler and hold firmly in place (**2**).

Move the ruler to the bottom of the sheet, align it correctly and bring the straight-edge to the end of the ruler again. Recheck to top measurement to ensure that the straight-edge has not moved.

Cutting

It is easier to cut exact measurements and true straight lines with a craft knife than with a pair of scissors. Always use a sharp blade and keep it upright and tight against the cutting edge of the straight-edge (**3**). The hand holding the knife should only press lightly – even if you have to cut several times until you get through a piece of cardboard. The other hand should hold the straight-edge very firmly.

Gluing

Lay a large sheet of scrap paper on the table and place the piece of paper you have just cut on to this, reverse side uppermost. Now, take a quantity of adhesive (see page 18) and apply it to the middle of the paper with a brush. Brush it evenly outwards towards the edges (**4**).

Let the adhesive soak into the paper for a short time, so there will be no creases, and in the meantime clean your hands with an old rag.

Press the paper down on to whatever you are covering, smoothing it down with the palms of your hands, the heel of your hand, or the edge of a bone folder (**5**). If your paper has a delicate surface, you should protect it with another layer of paper while you are rubbing it down.

1. Lay the ruler along the upper edge of the paper and slide it to the right.

2. Lay the straight-edge on the paper and butt it up against the end of the ruler.

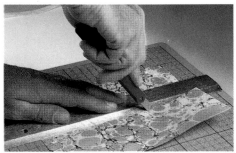

3. Put the ruler to one side, hold the paper still, and cut along the edge of the straight-edge with a craft knife.

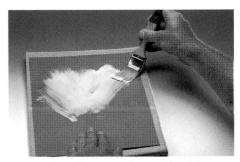

4. Put the adhesive in the middle of the paper and brush it evenly out towards the edges.

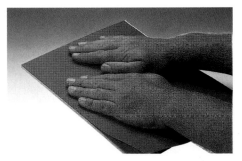

5. Place the paper on to your item and smooth it down well with your hands.

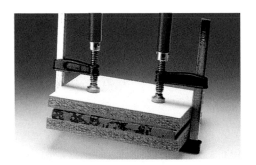

6. Place the item between two pressing boards and tighten the G-clamps evenly.

Many bookbinding tasks require glued surfaces to be pressed. If you do not have a press, use G-clamps. The number you will need depends on the size of what you are pressing. Lay the book or whatever between two boards, and apply the clamps so that each of them exerts equal pressure. This is done by tightening the clamps one after another, screwing the same number of times each time, until you have the desired degree of pressure.

Making your own decorative paper

You can easily make your own decorative paper to cover books, albums, portfolios or boxes. This chapter shows you how to make paper decorated with patterns made with paste, batik or by marbling.

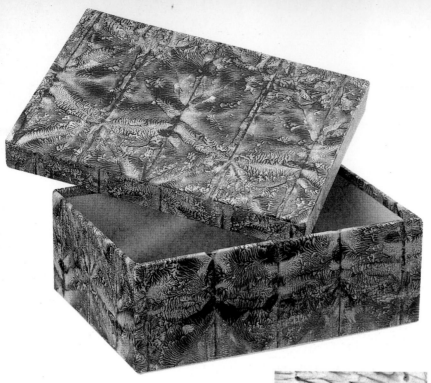

Paste patterns

Mix up the wallpaper paste the day before you need it, using the amount of water recommended by the manufacturers for hanging light wallpaper. Brush paste over the whole surface of a smallish piece of paper, and then, with another brush, paint some paint over the paste, again covering the whole sheet of paper. Now fold the paper in half, so that the painted surfaces are touching one another. Smooth down the paper on the reverse, and then unfold it. You will see that you have created a coloured pattern with a streaky effect (see paper No. 1 on the opposite page).

If you like the results, try this technique on a large piece of paper.

The papers shown on these two pages show you the sort of decorative variations you can make using this technique.

You can change the size of the patterns by altering the consistency of the paste. The more you thin it, the bigger the streaks become.

You can also use several colours on the paste instead of just one, or paint the paper with background stripes and then fold it in pleats (see paper No. 2).

Or, when you have folded the paper, draw lines on the back with a pencil or bone folder (papers No. 3 and No. 4). Alternatively, crumple the paper after you have added the paint, then smooth it out again (paper No. 5).

You will need:

old newspapers, (to use as scrap paper to protect your work surface)

wallpaper paste

Paints that are waterproof when dry, such as acrylics or tempera

two brushes,

Ingres paper

shallow bowl or palette for mixing paint

Thin paste will give you large streaks.

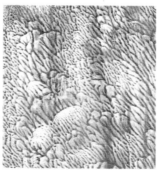

Thick paste will give you small streaks.

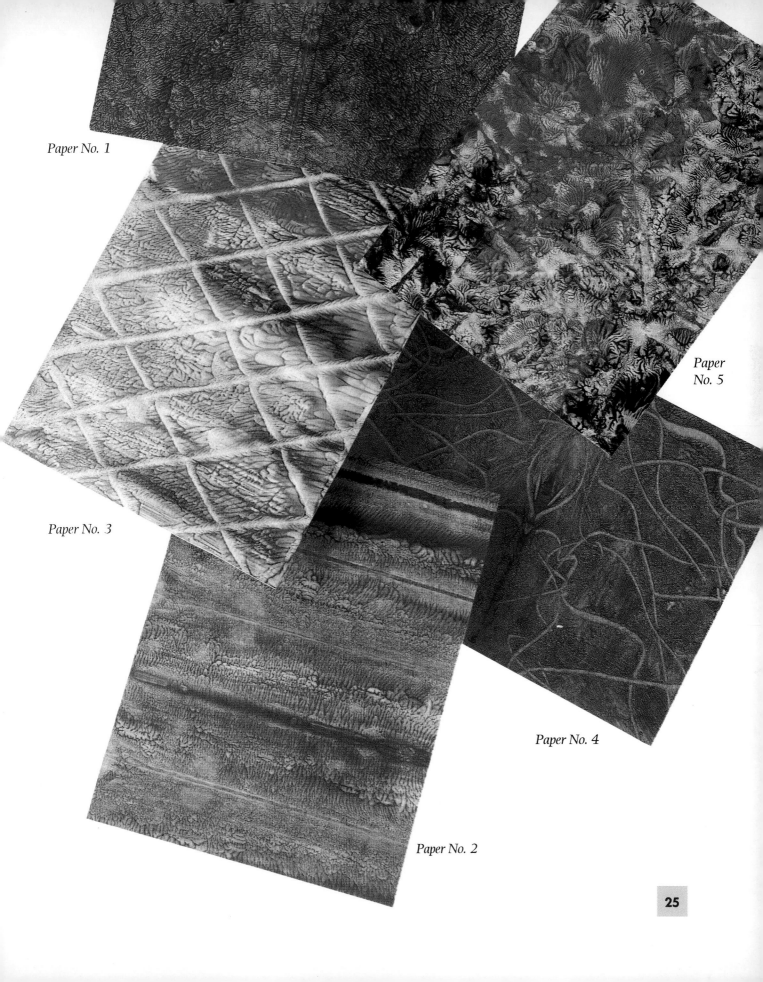

Paper No. 1

Paper No. 3

Paper No. 2

Paper No. 4

Paper No. 5

25

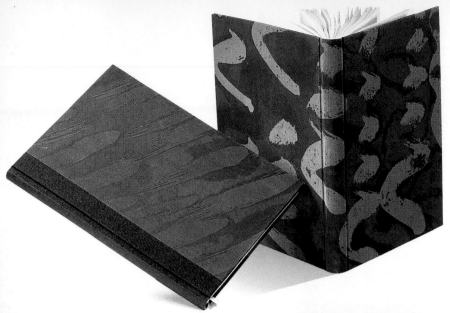

You will need:

old newspapers

batik wax (from craft shop)

a wax pot (or a large pan and a small old one)

paints that are waterproof when dry (such as acrylics or tempera)

firm white or coloured paper

a brush to apply the wax

soft, broad brush to paint the colour on to the paper

old jam jars for mixing paints

Batik paper

Warm some wax in a wax pot until it is liquid (about 50-60°C (120–140°F). You can also melt wax over hot water. Put the wax in a small old saucepan which you have placed inside a large pan of water heated on the cooker. Never heat wax directly in a single saucepan, because it might get too hot and burn.

Cover your work surface with old newspapers to protect it and then lay the sheet of paper to be coloured on it. Now paint melted wax on the paper using a brush – make drips, spattered drops or streaks; just as you wish (**1**).

Then put some paint in a jar and thin it with a little water. Paint the whole sheet of paper. Where the wax was applied, the paint will run off. If the wax gets completely covered, the paint is too thick and needs thinning some more.

When the paint is dry, place the paper between sheets of old newspaper and iron it all over on a cotton setting. The warmth will melt the wax again and it will be absorbed by the newspaper. Iron until all the wax has melted (**2**).

Try making multi-coloured batik paper, too: thin each colour of paint in a separate jar, paint wax patterns on the paper, and then paint the paper all over with one of the colours. Let this dry, then put some more wax on the paper and paint another colour over the top of everything. Then iron as before.

1. *First paint the paper with a light colour and dribble wax on it.*

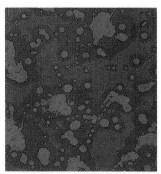

2. *Then paint the paper with a darker colour and iron out the wax. Now you can see the first colour again.*

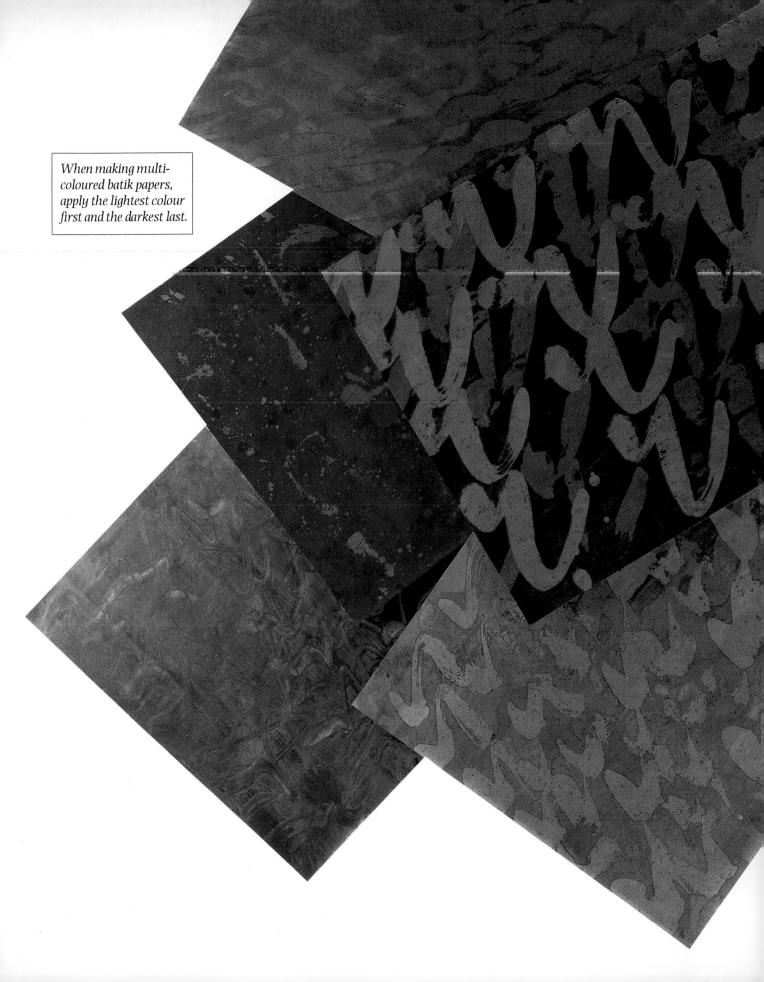

When making multi-coloured batik papers, apply the lightest colour first and the darkest last.

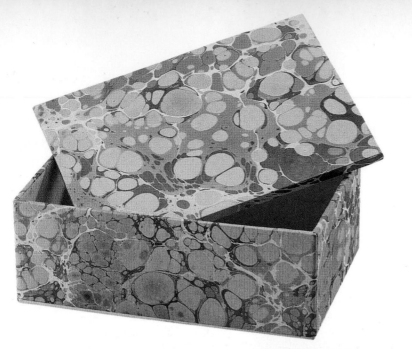

Marbled paper

The principle of marbling is very simple. You drop paint on the surface of a trayful of a thick solution of paste and then pick up the pattern with a sheet of paper.

The day before you want to marble, make up the paste by adding a dessertspoon of paste powder to each litre (2pt) of water you use. You will need enough paste to reach a depth of at least 30mm (1^1/$_4$in) in a shallow tray. It should be the consistency of cooking oil – stir it well.

Next day, mix your paints, thinning them with turpentine, using separate containers for each colour.

Test the consistency of the paint by letting a drop of paint fall from the brush on to the surface of the paste. The paint should spread out to form a circle about 30–40mm (1^1/$_4$–1^1/$_2$in) in diameter. If it is smaller than this, thin the paint a little more. If the paint spreads further (see left) add a little more paint to the pot.

Now drop the paint, using a different brush for each colour, on to the paste, one colour after another. When you have a pattern that pleases you, lay a dry sheet of paper (the paint will not adhere to a wet one) on to the surface of the paste. Take the paper by two opposite corners, allow it to bend slightly on the diagonal, and place it carefully on to the surface of the paste, lowering the corners evenly.

Lift the paper out of the tray, let the paste drip off it, and wash it thoroughly under cold running water. If there are any air bubbles, this is because you did not place the paper down evenly on the paste (see bottom left).

When you have dried the paper on a washing line, press it flat between boards.

You will need:

artists' oil paints in red, yellow, blue and black (you can mix all the other colours from these)

turpentine to thin the paints

glass jars for mixing paint

several fine brushes for dropping on the paint

a packet of wallpaper paste

a balloon whisk

a shallow plastic tray (at least 50mm (2in) longer and wider than the sheet of paper you are intending to marble)

strong paper (for example, Ingres paper)

If the paint is too thin, the blobs of colour will get too big.

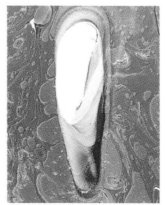

If you do not lay the paper down on the paste properly, you can get air bubbles.

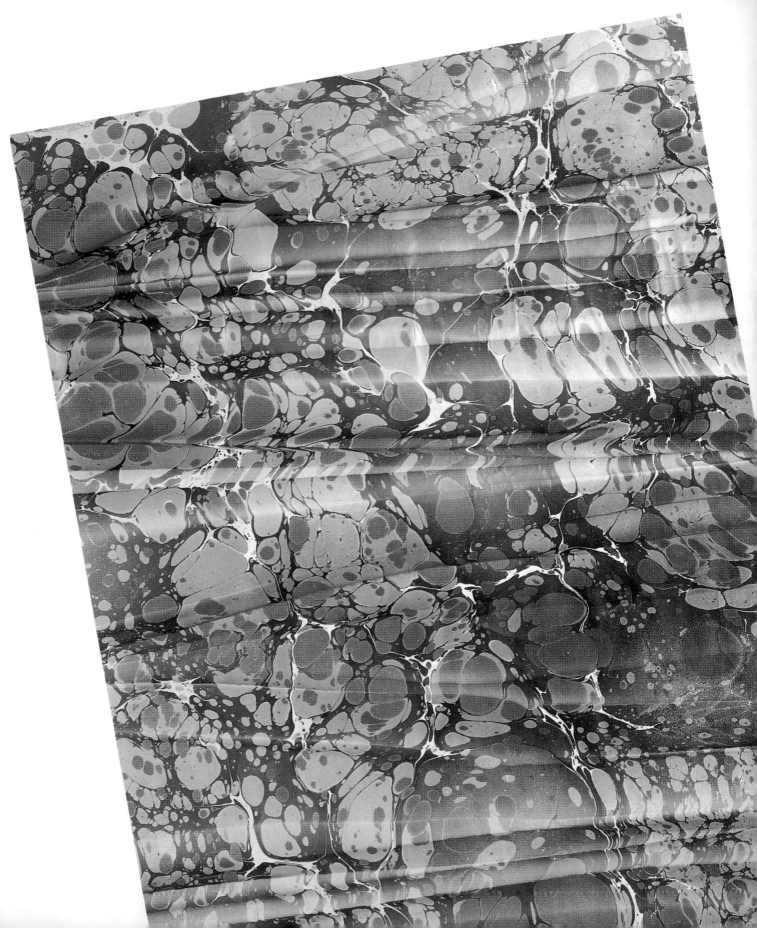

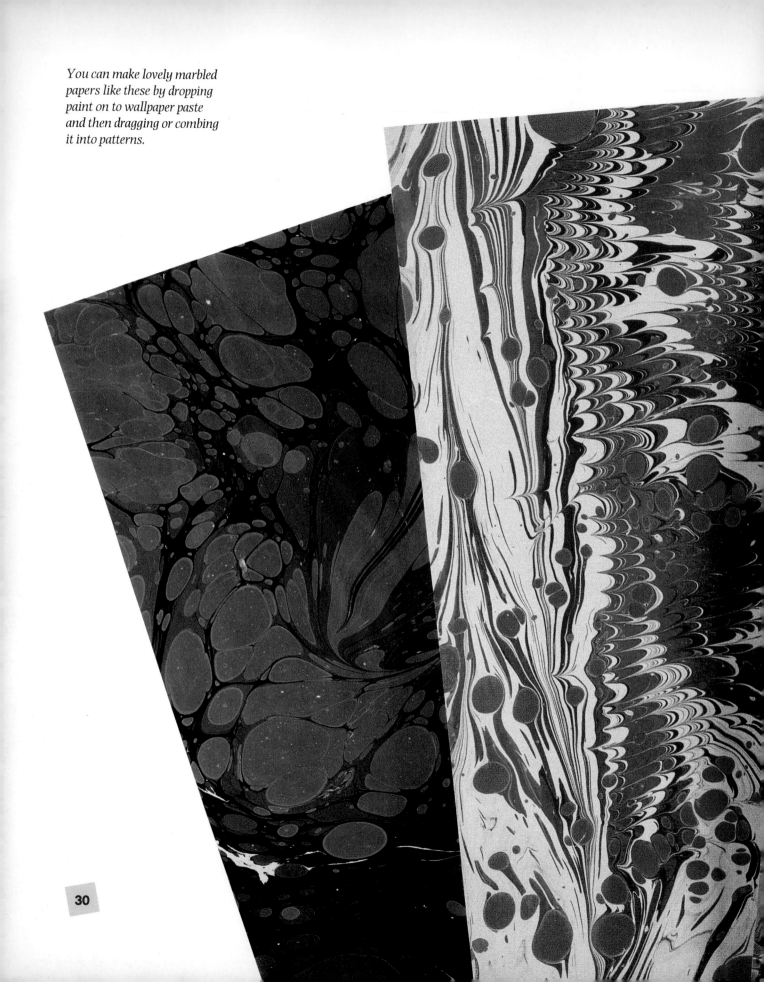

You can make lovely marbled papers like these by dropping paint on to wallpaper paste and then dragging or combing it into patterns.

30

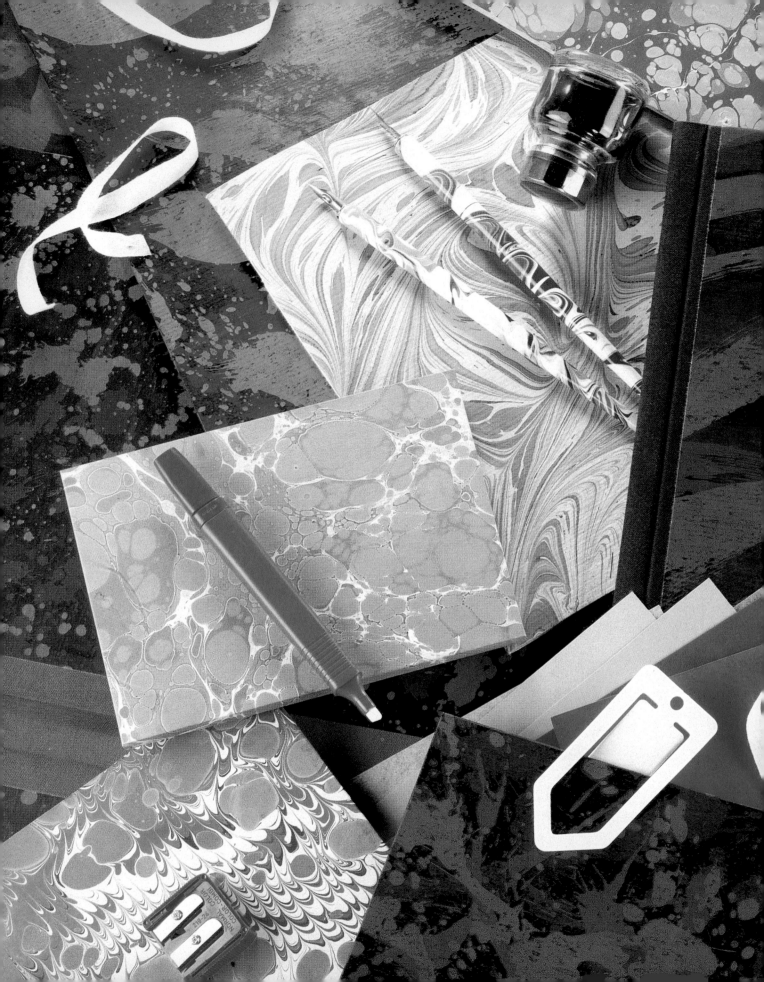

Notebooks, boxes, portfolios and albums

Now that you have learnt the basic techniques, and how to make your own decorative papers, you can start on practical projects. This chapter shows you how to make notebooks, decorative boxes, portfolios, beautiful photograph albums and leporellos.

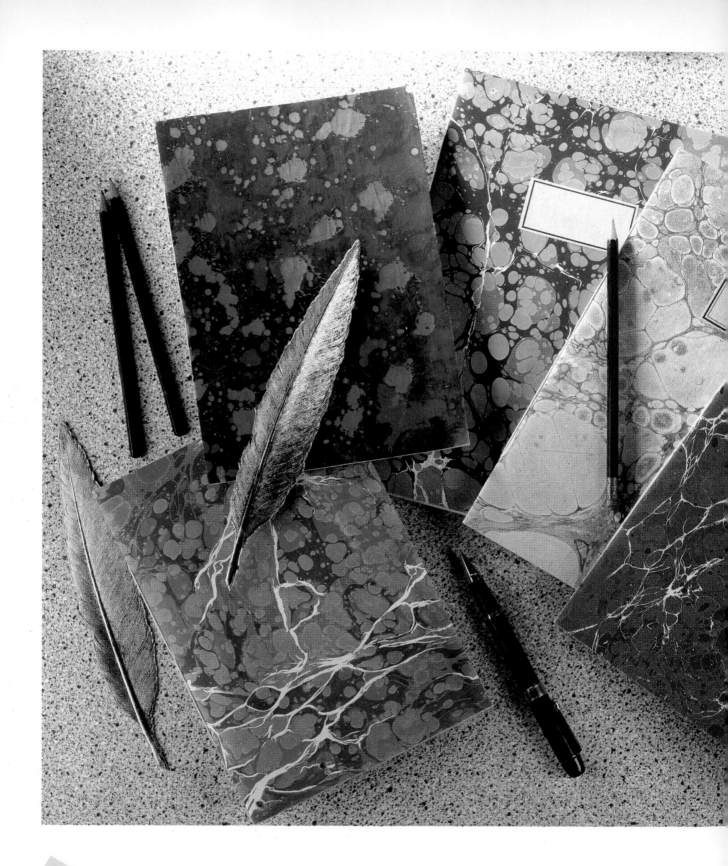

34

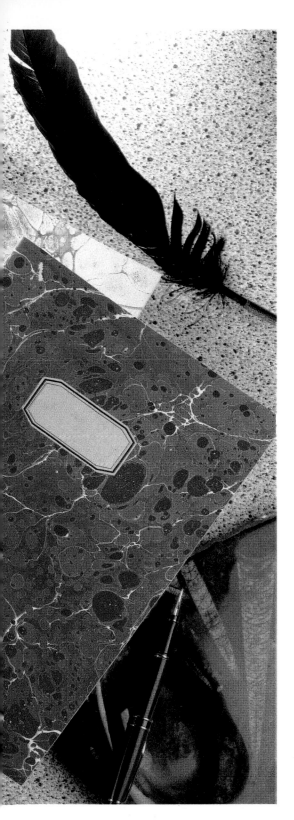

Notebooks

Notebooks or exercise books are always useful – they are versatile and can be used for recipes or important dates, or as vocabulary books for school.

Those shown here have only a few pages, so beginners can make them easily. You can also make thicker ones, of course, but you will need to pre-bore the holes with an awl and trim the stepped front edges of the paper with a craft knife or guillotine.

For the cover, you can use coloured card, sturdy coloured paper or wrapping paper, even thick wallpaper if you like. The insides of the book do not have to be white paper – you can use coloured Ingres paper or brown paper. You could even cut the paper into different shapes, such as round or heart-shaped, for a truly individual look.

At the back of this book you will find a selection of decorative labels which you can photocopy and reduce or enlarge to the desired size and then cut out and stick on the front of your notebook.

You will need:

four sheets of A4 size paper (about 8¹/₂ x 12in)

one sheet of sturdy coloured card (A4 size)

some strong decorative paper (A4 size)

strong sewing thread and a darning needle

Folding

Fold all the sheets of paper and the card for the cover in two, exactly down the middle, so that the two short sides are together. Now smooth the folds down with the bone folder.

Next, lay the sheets of paper one inside another along the fold – bookbinders call this a section – and lay them inside the folded card cover.

Sewing

Sew all the sheets of paper together, at the same time sewing them to the cover. Lay the section with its folded edge on the side of a table – it is easier to work like this. With a needle or awl, pierce five holes along the innermost fold, from the inside.

Bore the holes from the inside through all the folds.

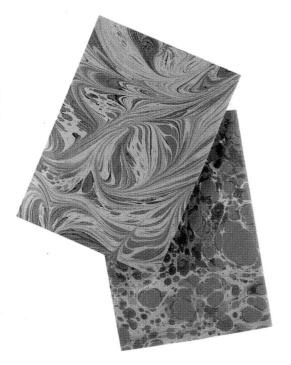

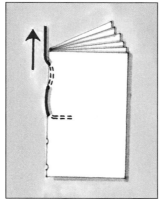

Always pull the thread taut in the direction of the fold.

The first and last holes should be 10mm ($^3/_8$in) from each end and the other holes should be equidistant from one another.

Now thread the needle with a piece of thread at least two-and-a-half times as long as the fold in the cardboard cover.

Start sewing from the inside: insert the needle through the centre hole, take it back through the next hole (**1**) and then out through the end hole (**2**).

Next, sew back down the fold missing out the centre hole, in through the next hole (**3**) and out through the next-but-one hole (**4**). Now take the needle through the bottom hole (**5**), come back up the fold and out through the next hole.

Finally, take the needle back through the centre hole (**6**). Pull the thread taut in the direction of the fold and knot the ends inside (**7**), cutting off any surplus.

The basic principle is that the holes should always be bored from the inside, going straight through all the folds at an angle of 45° to half the paper (see the diagram above – top left).

Pull the thread taut before every change of direction, pulling it in the direction of the fold, not downwards or upwards (see the diagram bottom left).

1. From the inside, sew through the centre hole to the outside, then back through the next hole.

2. Now stitch from the inside through the end hole.

3. From the outside, go back in the opposite direction into the next hole.

4. Now bring the thread from inside the book through the next-but-one hole.

5. Go back in through the bottom hole.

6. Working back up the fold, bring the needle out of the next hole and in through the centre one.

When pushing your needle through a hole through which you have already stitched, be careful not to pierce the previous thread with the needle, or you will not be able to pull it taut any more.

7. Pull the thread taut, parallel to the fold, tie a knot in the middle and cut off the ends.

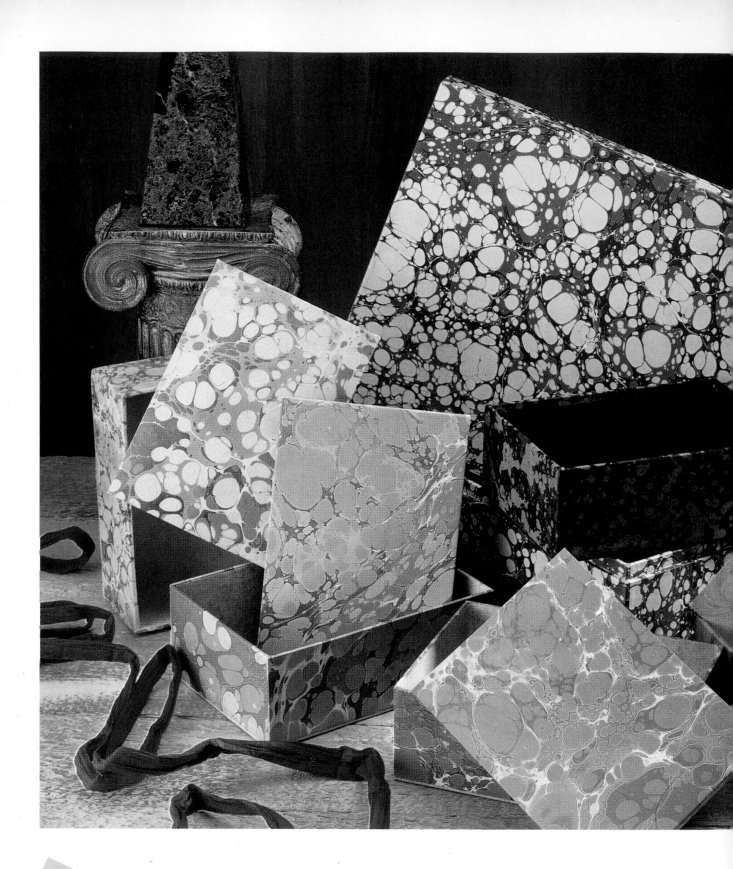

Boxes

Over the years, bookbinders have learnt to make all sorts of boxes. Here I show you how to make a box to which you can add one of two different types of lid .

Measurements and cutting

Greyboard is strong and easy to cut, and so is ideal for making boxes.

For the bottom of the box you need five pieces of board: the base, two sides and two ends. For this exercise, they can be cut from a 250 x 300mm (10 x 12in) sheet of 2mm (¹/₁₆in) greyboard.

The papers you are going to cover the boxes with must be measured and cut, too. Use a textured paper for the inside lining of the box and decorative paper for the outside.

For a lid that overhangs the box, use the same method as for the bottom, but with different measurements.

For a lid that sits flush on the top of the box and no flaps, you will need two pieces of card and different papers.

You will need:

2mm (1/16in) thick greyboard – see page 40 for the sizes required

textured paper – see page 40 for sizes required

Decorative paper – see page 40 for sizes required

scrap paper

brush and bookbinder's adhesive

adhesive tape

sandpaper

Making the base

Cut out all greyboard pieces to the sizes given in the list below. Then brush adhesive all over the 250 x 300mm (10 x 12in) sheet of textured paper for the lining of the box. Let the adhesive dry, then apply another coat. Now lay all the pieces of cardboard beside each other on the textured paper and press them using boards and weights until the adhesive is dry. Cut through the paper along the edges of the board pieces.

Glue all four edges of the covered base and the short edges of the two covered side walls of the box (**1**).

Stick two pieces of adhesive tape on each side on the base so that half of the tape is free (**2**). These pieces of tape are to stabilise the box while you are making it and will be removed later.

For step-by-step illustrations showing how to make and then cover boxes refer to pages 42 and 43.

Place one side wall up against one long side of the base and press the tape down lightly on to the side walls (**3**). Do the same with one of the end pieces against one of the short edge of the base. Tape across the outside of the corner to stabilise it (**4**). Then fix the second long side (**5**). When you attach the second end piece, to complete the rectangle, tape both corners on the outside (**6**).

When the adhesive is dry, remove all the strips of tape and smooth down any rough edges with sandpaper.

Covering the base

Now cover the outside of the box – this not only makes it look attractive but also strengthens the box. Cover all four side walls with decorative paper, but use textured for the bottom.

Overhanging lid: inside view.

Cutting instructions:

Greyboard
- 160 x 115mm ($6^1/_4$ x $4^1/_2$in) – box base
- 160 x 60mm ($6^1/_4$ x $2^3/_8$in) – box sides (two off)
- 119 x 60mm ($4^5/_8$ x $2^3/_8$in) – box ends (two off)
- 167 x 122mm ($6^3/_4$ x $4^3/_4$in) – top of overhanging lid
- 167 x 20mm ($6^3/_4$ x $^3/_4$in) – sides of overhanging lid (two off)
- 126 x 20mm ($4^5/_8$ x $^3/_4$in) – ends of overhanging lid (two off)
- 164 x 119mm ($6^3/_8$ x $4^3/_4$in) – top of flush lid
- 157 x 112mm ($6^1/_8$ x $4^1/_8$in) – bottom of flush lid

Textured paper
- 250 x 300mm (10 x 12in) – box lining
- 140 x 180mm ($7^1/_8$ x $5^1/_2$in) – box base
- 200 x 250mm (8 x 10in) – overhanging lid lining
- 142 x 187mm ($5^5/_8$ x $7^3/_8$in) – flush lid

Decorative paper
- 74 x 184mm (3 x $7^1/_4$in) – box sides (two off)
- 74 x 117mm (3 x $4^1/_2$in) – box ends (two off)
- 146 x 191mm ($5^3/_4$ x $7^1/_2$in) – overhanging lid top
- 30 x 191mm ($1^1/_8$ x $7^1/_2$in) – overhanging lid sides (two off)
- 30 x 124mm ($1^1/_8$ x $4^7/_8$in) – overhanging lid ends
- 150 x 195mm (6 x $7^5/_8$in) – flush lid

Brush adhesive over the other sheet of textured paper and place the base of the box in the middle of it, so that the paper is visible around all four sides of the box. At each corner of the box, cut out a narrow triangle on the short side of the paper (**7**). Now fold up the two strips of paper along the long sides as shown in (**8**) and glue them down, turning the flaps round the corner. Glue the short strips on the ends of the box in a similar fashion.

Now glue one of the long strip of decorative paper all over and glue it on one of the side walls 2mm ($^1/_{16}$in) up from the bottom of the box; allow it to protrude over the top edge of the side wall (**9**). Again, the overlap comes round the corners a short way and is also glued down. Cut a small triangle of paper out of the protruding paper and fold the flaps in: first the short overlapping pieces (**10**), then the long flaps (**11**).

Glue the second strip on the second long side in the same way then, finally, cut the other two pieces of decorative paper to the exact width of the ends of the box and glue them as before (**12**). The box is now finished, but leave it to dry for at least twelve hours.

Overhanging lid

The overhanging lid is made in the same way as the base of the box except that the top of the lid is covered in decorative paper rather than textured paper. Try the lid on the box before you cover it to see if it fits properly and comes off again easily. If not, rub it down with sandpaper where it sticks.

Flush lid

Cut out the two pieces of greyboard, the decorative paper and the textured paper as instructed. Glue the back of the decorative paper all over and place it on the larger piece of cardboard – the top of the lid. Then cut off the four corners of the paper (that which extends beyond the board) diagonally to within 2mm ($^1/_{16}$in) of the corners of the board. Fold in the surplus paper of the long sides, then the short sides, and glue it down to the other side of the cardboard.

Cover the second piece of card in a similar way using textured paper. Glue the two covered boards together so that the smaller is centred on the larger – see below right.

Finally, press the finished lid flat using two pressing boards and a pair of G-clamps.

Flush lid: view from below.

Flush lid: side view.

Gluing the paper you are covering the box with twice makes sticking it on much easier. Here we are doing it with the textured paper. When you put the first coat of adhesive on, it impregnates the paper, which then expands and corrugates slightly in the direction of the grain. When you glue it the second time it does not move any more, and the glue dries more slowly, giving you more time to work with the paper.

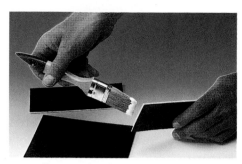

1. Following the photograph, glue the four edges of the bottom of the box and the short edges of the two long sides.

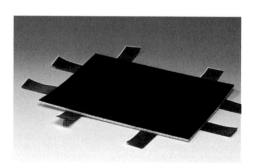

2. Stick two pieces of adhesive tape to each edge of the bottom of the box, on the underside.

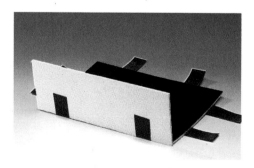

3. Place one side against a long edge of the bottom of the box and tape it in position.

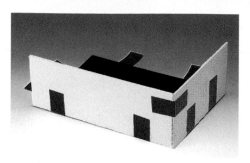

4. Fix one of the ends and tape the corner on the outside to stabilise it.

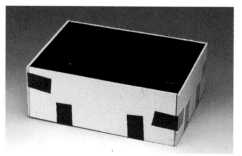

5. Attach the second side to the base and tape the corner.

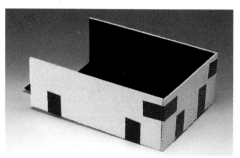

6. Now put the second end in place and tape both corners.

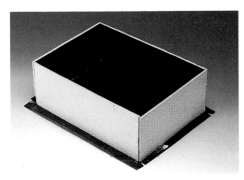

7. Cut a triangle out of each corner of the textured paper at the corners of the box.

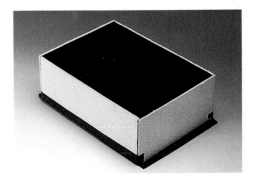

8. Fold up the two long strips and glue them to the sides, turning the flaps round corner. Fold up end flaps.

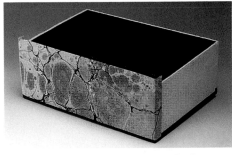

9. Starting 2mm ($^1/_{16}$in) from the bottom of the side, glue on a piece of decorative paper and wrap the side flaps round on to the ends.

10. Cut out two triangles, fold the short flaps over the ends of the box and glue them down.

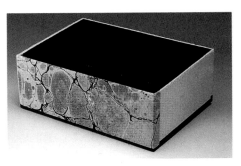

11. Turn over the long flap on the side and glue it down.

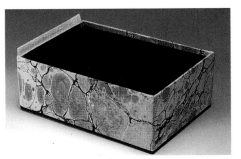

12. Repeat stage 11 for the other long side and then, finally, glue the pieces of decorative paper to the ends of the box as shown.

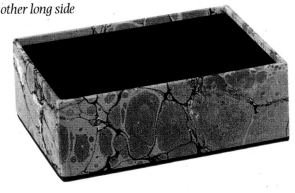

When assembling the box, make sure that there are no gaps between the edges. You can check this by holding the box up to the light. If you see any light shining through, fill the gap with adhesive and hold the joint in place with adhesive tape until the adhesive has set.

Portfolios

Keep your drawings, prints, decorative papers, newspaper articles or writing paper safe and free from dog-ears by storing them in portfolios you have made yourself. This one is made to store A4-size (about 8¹/₂ x 12in) paper.

Cut out all the pieces to the measurements given (opposite). When cutting the bookcloth, make sure that the warp runs parallel to the long side of the binding (see page 17).

Making the portfolio covers

Glue the whole of the back of the longer piece of bookcloth and place the strip of thin card in the middle (**1**). Then stick the two pieces of millboard (the portfolio covers) on to the cloth, butting them up against the strip of thin card on both sides. Turn in the overhanging pieces of bookcloth at the top and bottom of the board and stick them down firmly (**2**).

On the inside of the spine you have just made, stick the second piece of bookcloth so that it is equidistant from the top and the bottom of the spine. Now rub the cloth into the edges of the board with the bone folder and rub down all the glued surfaces carefully. To make sure that the inner piece of glued cloth is properly stuck to the edges of the card, leave it to dry for a few minutes.

Covering the cover boards

Draw two vertical pencil lines on the outside of the spine cloth 5mm (¹/₄in) in from the edges of the bookcloth (**3**).

Glue a piece of decorative paper all over on the reverse side and lay it on one of the pieces of board so that the long side aligns with the pencil line (**4**). Rub the edge down well with the bone folder. Now cut off the corners of the overhanging paper diagonally, 3mm (¹/₈in) away from the

1. Stick the strip of thin card in the middle of the glued bookcloth.

2. Turn in the strips of cloth at the top and bottom and rub them down.

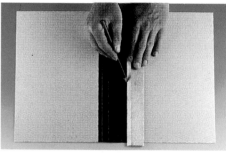

3. With a pencil, draw two vertical lines on the outer piece of bookcloth 5mm (¹/₄in) in from each side.

corners. Next, fold over the short edges of the overhanging paper, then the long ones, and stick them down, pinching in the corners as you do so (**5**).

Finally, turn the portfolio over and rub down the decorative paper firmly with the bone folder or the side of your hand, paying special attention to the edges. Now repeat the procedure with the second piece of board (the other cover). Leave the portfolio to dry for a short time between two large pressing boards.

For added strength, you can reinforce the corners with cloth as well.

Adding ribbons

The next thing is to make slots for the ribbons. Draw the cutting lines on the inside of the covers with a pencil. They should be as long as the width of the ribbon you are going to insert – in this case 10mm ($^3/_8$in) – and 10mm ($^3/_8$in) from the edges of the portfolio. You will need six slots in all – three in each cover. They should be placed in the middle of each edge of the covers and cut parallel to their respective edges.

Starting from the outside, thread one ribbon through each slot, until you have 20mm ($^3/_4$in) of ribbon on the inside (**6**). Glue the ribbons to the board with a little adhesive.

For the insides of the covers, stick some textured paper over them, keeping the paper central on each cover.

Place the portfolio between the two pressing boards, and put some weights on top, and leave to dry for about 24 hours.

Cutting instructions

bookcloth
80 x 350mm (3$^1/_8$ x 13$^3/_4$in)
80 x 314mm (3$^1/_8$ x 12$^3/_8$in)

strip of paper
30 x 320mm (1$^1/_8$ x 12$^1/_2$in)

millboard (two off)
225 x 320mm (8$^3/_4$ x 12$^1/_2$in)

decorative paper (two off)
220 x 350mm (8$^1/_2$ x 13$^3/_4$in)

textured paper (two off)
200 x 310mm (7$^3/_4$ x 12$^1/_4$in)

ribbon (six lengths)
250mm (10in) long

4. *Stick a piece of decorative paper on the outside of one of the covers, lining it up with the pencil line.*

5. *Cut off the corners of the paper diagonally. Fold in the flaps of paper, and stick them down.*

6. *Make six slots for the ribbons and thread them through.*

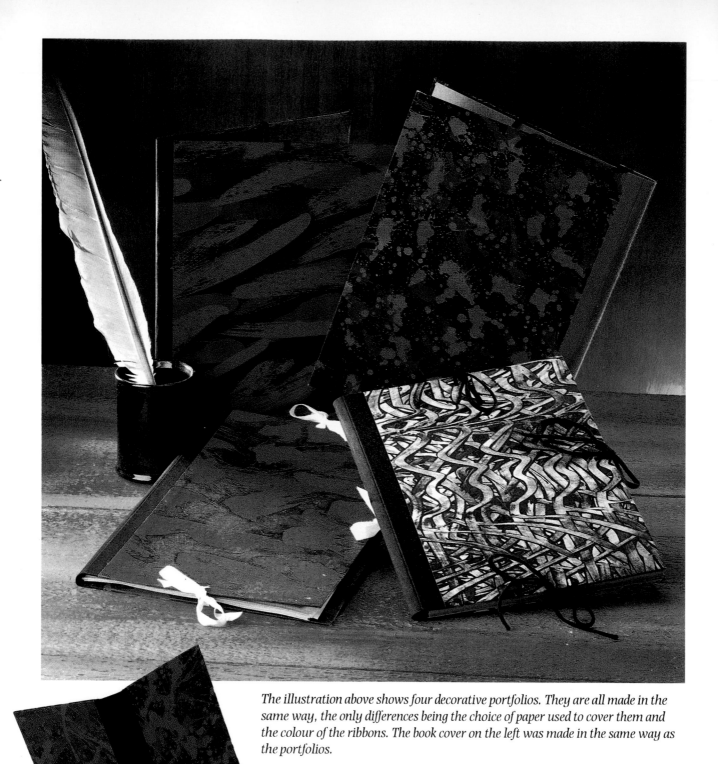

The illustration above shows four decorative portfolios. They are all made in the same way, the only differences being the choice of paper used to cover them and the colour of the ribbons. The book cover on the left was made in the same way as the portfolios.

Above, you can see what the portfolios look like inside and out when they are opened up. If you put writing paper in your portfolio, it can be white or in colours chosen to go with the decorative paper on the cover. On the left, once again, is a hand-made book cover made in the same way as the portfolios.

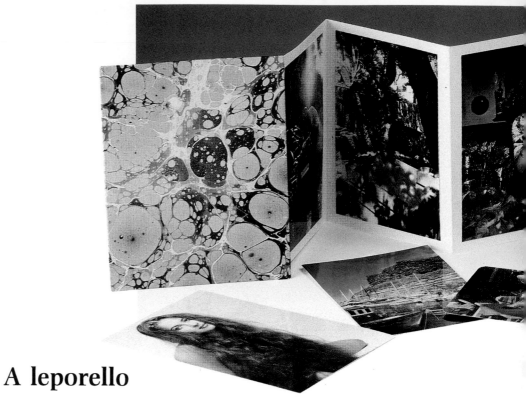

A leporello

A leporello is a concertina-folded piece of paper or card – the name comes from the list of Don Juan's lovers in Mozart's opera Don Giovanni (Leporello was the name of his servant, who made the list). But this method of folding predates Mozart by some centuries, as it was known to Japanese bookbinders in ancient times.

You can use leporellos for many purposes: as photograph albums, as unusual greetings cards, or as notebooks or sketchbooks, to name but a few.

The inside of the leporello is made of stiff card. Here we are using photograph-album card, which is available in black, white, grey or a variety of colours. The colour of the decorative paper you use for the covers should tone in with the colour of the card used for the inside. If you want to write or paint on the insides of the leporello, use Ingres paper or something similar instead of card.

Making the leporello block

Take one of the strips of card and mark the middle point of the long side. Align a T-square against the mark and make a crease across the strip with a bone folder. Fold the strip in half and use the bone folder to make a good folded edge. Mark the middle of the folded strip, make a crease and fold back the top layer of card. Turn the strip over and make the third fold. Fold the other three strips in a similar way.

Open up two of the strips and trim 2mm (¹/₁₆in) off each end. Open up the other two and trim 2mm (¹/₁₆in) off one end only.

Glue the four strips together as shown in the photograph opposite, making sure that the untrimmed pages are at the outer ends of the combined strip.

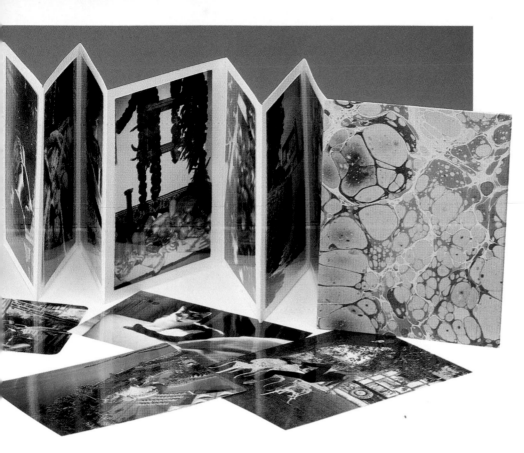

Cutting instructions

stiff card (four off)
170 x 480mm (6¹/₂ x 20in)

millboard (two off)
128 x 178mm (5¹/₄ x 6³/₄in)

decorative paper (two off)
160 x 210mm (6¹/₂ x 8in)

kraft paper (two off)
115 x 165mm (4³/₄ x 6¹/₄in)

The cover

Cut the two pieces of millboard, the two pieces of decorative paper to cover them, and the two pieces of brown paper, according to the measurements given. The method of covering a cover with paper has already been given on page 44. When making a leporello, you should cut off all the corners of each piece of decorative paper and fold over all four edges. The drying time is about two hours.

Now stick a piece of brown paper on the inside of each cover and then glue the outer folds of card to these.

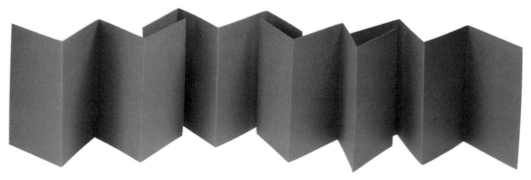

The four folded strips of card are assembled and glued together like this.

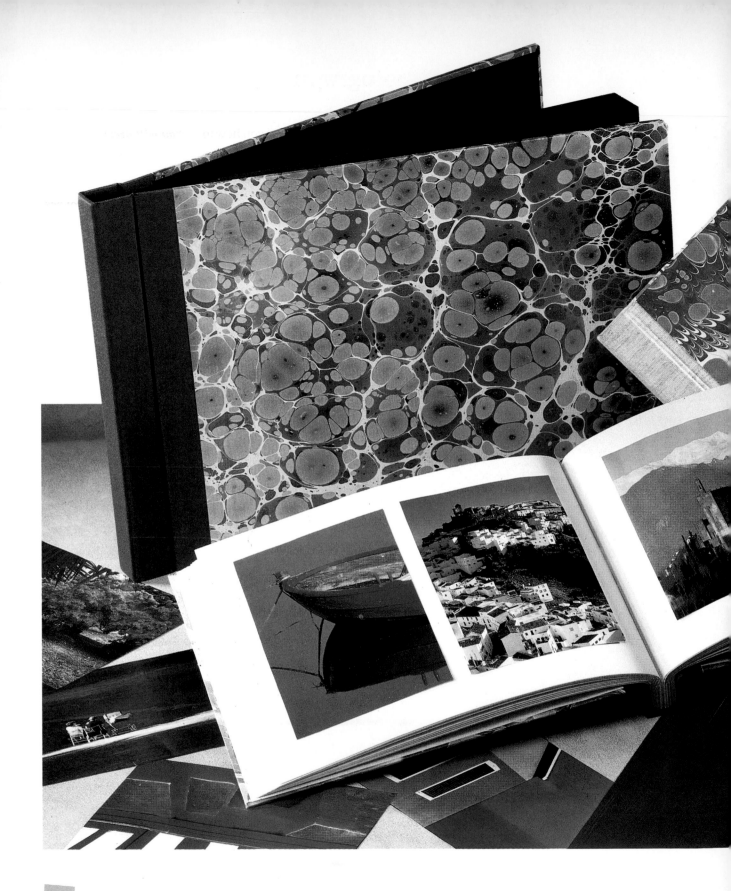

Photograph albums

On pages 48 and 49 I showed you how to make a leporello, which can be used as a photograph album. Now I am going to show you how to make a classic photograph album.

You can size your album to suit your own particular requirements but to help you get organised I have given cutting instructions for two sizes, both of which can be found on page 52.

For the leaves of the album you will need a stiff heavyweight paper or thin card that will support the weight of the added contents, preferably with a short grain on the cut sheets.

You do not have to use white card for the pages of the album – use black or coloured card if you like, to tone with the colours of the paper on the cover and the book cloth on the spine. This looks particularly attractive.

If you do not want to make your own decorative paper (see page 22 onwards), use gift wrap or textured paper.

You will need:

Good-quality thin card or a heavy cartridge paper for the pages of the album

millboard for the covers

bookcloth for the spine

decorative paper

textured paper

scrap paper

greyboard

old newspapers

51

Cutting instructions for the small album

thin card
 album pages (twenty) 175 x 250mm (6^1/$_2$ x 10in)
 compensation guards (twenty) 18 x 175mm (5/$_8$ x 6^1/$_2$in)

bookcloth
 120 x 210mm (4^3/$_4$ x 8^1/$_4$in)
 120 x 175mm (4^3/$_4$ x 6^1/$_2$in)

millboard
 covers (two) 181 x 228mm (6^3/$_4$ x 9^1/$_8$in)
 spine sides (two) 18 x 181mm (5/$_8$ x 6^3/$_4$in)
 spine 181mm (6^3/$_4$in) long cut to a width equal to the
 thickness of the glued bookblock

decorative paper
 (two) 210 x 238mm (8^1/$_4$ x 10in)

textured paper
 (two) 175 x 220mm (6^1/$_2$ x 9in)

Cutting instructions for the large album

thin card
 album pages (twenty) 250 x 350mm (10 x 13in)
 compensation guards (twenty) 18 x 250mm (5/$_8$ x 10in)

bookcloth
 120 x 2850mm (4^3/$_4$ x 12^1/$_8$in)
 120 x 250mm (4^3/$_4$ x 10in)

millboard
 covers (two) 256 x 328mm (10^1/$_4$ x 12^1/$_8$in)
 spine sides (two) 18 x 256mm (5/$_8$ x 10^1/$_4$in)
 spine 256mm (10^1/$_2$in) long cut to a width equal to the
 thickness of the glued bookblock

decorative paper
 (two) 285 x 338mm (11^1/$_4$ x 12^3/$_4$in)

textured paper
 (two) 250 x 320mm (10 x 11^7/$_8$in)

Making the bookblock

Unlike sewn bookblocks, this one is made from single sheets of thin card which are glued together at the spine edge to form a solid block. Narrow strips of card (compensation guards) are interleaved and glued between the pages to allow the book to lie flat when the photographs are fixed to the pages. To allow the pages to open freely a hinge, in the form of three vertical creases, is made on each page of the bookblock. The cover is also made in a slightly different way, too; this one will incorporate inset hinges. Step-by-step photographs of the procedure are given on pages 54 and 55.

Lay a sheet of card on a piece of greyboard and make three creases with a straight-edge and the bone folder parallel to the short edge: make the first crease at 20mm (3/$_4$in) in from the left-hand side (**1**); the second at 23mm (7/$_8$in); and the third at 26mm (1in) in. Do the same on the other nineteen sheets.

Glue the compensation guards and stick them to the sheets of card, aligning each at the top, bottom and left-hand edges of each sheet (**2**). Rub the guards down well with a bone folder.

Using a piece of scrap paper to protect the pages of the album, apply adhesive to the top of the compensation strip (**3**). Remove the scrap paper and carefully place a second page on top of the first, making sure that it sits square all round. Continue with the other pages.

When all the sheets have been glued together, place the block between two pressing boards and secure with G-clamps placed at the glued end of the bookblock (**4**).

Making the case

Measure the thickness of the bookblock and cut a 181mm (7^1/$_8$in) length of millboard to this width.

Glue out the back of the large piece of bookcloth, place it face down on your work surface and then lay the spine-width piece of millboard in the middle of the bookcloth. Place the other two strips on either side of the first piece leaving gaps of 2mm (1/$_{16}$in) between each. Finally, place the two cover boards on either side, leaving a gap of 7mm (1/$_4$in) (**5**). Make sure that the gaps are equal down their lengths and that all the pieces of millboard are aligned at the top and bottom. Fold in the bookcloth flaps at the top and bottom and rub them down with the bone folder. Turn the cover over and rub the cloth down firmly with the bone folder, working the cloth into the gaps between the boards.

Glue out the second piece of bookcloth and fix it centrally (top to bottom) on the inside of the cover (**7**).

Decorating the case

Glue the back of a piece of decorative paper all over (place scrap paper under it while you are working) and let the glue soak in for a few minutes. Then stick the paper on the outside of one of the cover boards so that its left-hand short edge comes within 5mm (1/$_4$in) of the nearest groove in the book cloth (the hinge). The paper should overhang equally at top and bottom of the cover (**8**). Now turn the cover over and cut off the right-hand corners (diagonally) 2mm (1/$_{16}$in) from the cover board (**9**).

Next, turn in one of the long overhanging flaps, then the other and finally turn in the short flap (**10**). Place some protec-tive paper over the cover and rub down with the bone folder, not forgetting the flaps of paper on the inside. Cover the other cover board in a similar way.

Glue out a piece of textured paper and stick it on the inside of the cover so that there is an equal gap all round (**11**). Stick another piece on the other half of the cover. Place the covers between two sheets of greyboard and pressing boards, add some weights and leave to dry for at least an hour.

Casing-in

Now attach the cover to the album block. Apply an 18mm (5/$_8$in) wide strip of adhesive to the front and back of the bookblock at the spine edge (**12**).

When the glue has soaked into the card, wrap the cover around the book-block so that it is equidistant from the top and the bottom of the spine.

Finally, place the album between two boards and press it using two G-clamps. Make sure the G-clamps are positioned exactly over the glued strips of card. Leave to dry for an hour, and your album is finished!

You can make your album even more special by interleaving the pages with sheets of spider's-web-patterned tissue paper. For the small album, cut the sheets 165 x 240mm (6 x 9$^1/_2$in) and for the large one 240 x 340mm (9$^1/_2$ x 12$^1/_2$in). Glue each sheet in place when you are building up the bookblock, leaving a 5mm ($^1/_4$in) border all round.

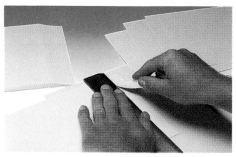

1. Make three grooves in each sheet of card with the bone folder.

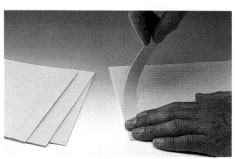

2. Stick a compensation guard to each page, on the left-hand side.

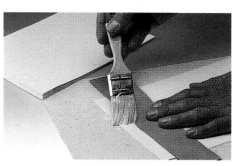

3. Build up the bookblock by gluing the sheets together on the spine side.

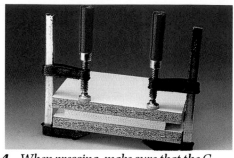

4. When pressing, make sure that the G-clamps are placed directly over the strips.

5. Place the spine strips and cover boards on to the glued bookcloth.

6. Rub down the bookcloth all over, and in the gaps between the pieces of board.

10. *Fold in the flaps.*

7. *Glue the second piece of bookcloth to the inside of the spine.*

11. *Glue a piece of textured paper to the inside of each cover.*

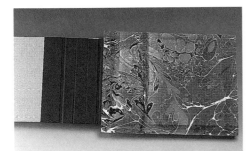

8. *Glue a piece of decorative paper on to the outside of the cover.*

9. *Cut off the corners of the paper diagonally on the right-hand side.*

12. *Glue the front and back of the bookblock at the spine edge and then assemble the cover to the bookblock.*

Making your own books

Making a book is really not very difficult. I show you the different sorts of binding and how to do each of them, step by step. First of all I explain how a book is made, and then I show you how to make a bookblock of paper and a cover — and how to put them together.

What is a book?

A book is no more than lots of sheets of paper bound together within a cover. Generally, a book consists of several folded sheets of paper sewn together to form the **bookblock**. This is protected by a **limp wrapper** (a paper or thin card cover) or a **case** (hard cover). A case consists of two cover boards which are separated from one another by a spine. The cover boards can be covered with bookcloth, paper or other materials. Depending on how these are applied, bindings are divided into different categories, such as quarter-, half- and full-cloth bindings.

For cased books with a **full-cloth binding**, a single piece of bookcloth is used to cover the complete case.

Quarter-cloth bindings have bookcloth covering the spine, and a decorative paper on the cover boards. **Half-cloth bindings** are basically the same, but include pieces of cloth on the fore-edge corners, or a strip of cloth down the full length of the fore-edge.

There are numerous ways in which the pages of a book can be fastened together. In this chapter I show you two possibilities: **sewing**, with tapes (page 62), and **gluing** (page 74 onwards). Before we go on to make a quarter-bound book, I would like to show you just how a book is constructed. This is where you get to learn and understand some useful and important technical terms.

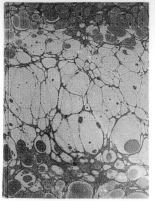

Limp binding.

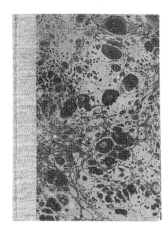

Quarter-cloth binding.

Full-cloth binding.

How a book is constructed

The photograph on page 59 shows you the different parts of a book. First there are the two main parts of a book: the bookblock and the case. The case consists of the spine (**1**) and the two cover boards (**2**).

The cover is made of millboard – one piece for each cover board. Where the side of one piece of board adjoins the spine there is the cover fold, also known as the hinge (**3**). The three free sides of the board are the edges (**4**) of the cover. The head band (**5**) is part of the spine. A 'proper' book also has a bookmark.

The bookblock

Now let us have a closer look at the bookblock.

The edge opposite the spine is called the fore-edge (**6**), the top is the head (**7**) and the bottom the tail (**8**). The distance from the head to the tail is known as the height of the bookblock (**9**), that from the spine to the fore-edge its width (**10**), and that from the first page to the last its thickness (**11**). The endpapers (**12**) are also a part of the bookblock.

The case

In the photograph on page 59, you can also see that the cover boards (**2**) are covered with decorative paper (**13**). The spine insert (**14**), usually a thin strip of card, gives the spine more strength.

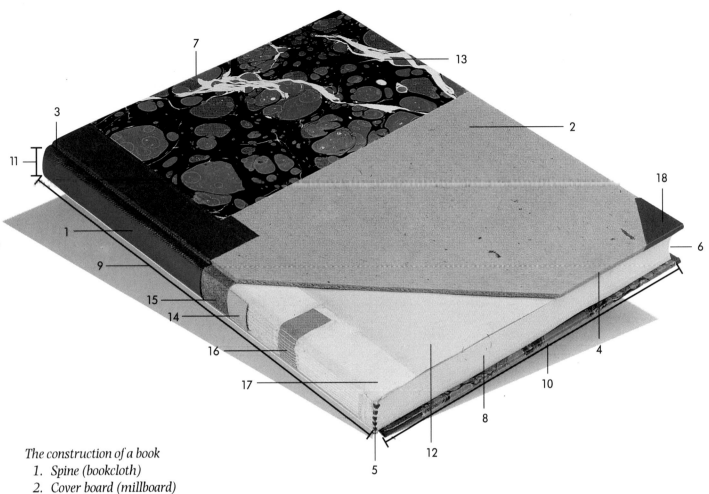

The construction of a book
1. Spine (bookcloth)
2. Cover board (millboard)
3. Cover fold (hinge)
4. Edge
5. Headband
6. Fore-edge
7. Head
8. Tail
9. Height of the bookblock
10. Width of bookblock
11. Thickness of bookblock
12. Endpaper
13. Decorative paper
14. Spine insert
15. Binding strips
16. Sewing tape
17. Mull
18. Bookcloth corners (half-cloth binding)

Making a bookblock

You will need:

forty sheets of white paper A4 size (about $8^1/_2$ x 12in)

two sheets of Ingres paper A4 size (about $8^1/_2$ x 12in)

two pieces of mull each 30 x 210mm ($8^1/_2$ x $1^1/_4$in)

three strips of calico each 100 x 10mm (4 x $^3/_8$in)

two pieces of millboard 1.5mm ($^1/_{16}$in) thick, each 250 x 350mm (10 x $14^1/_4$in)

two pieces of thin card and brown paper, each 250 x 100mm (10 x 4in)

bookcloth 250 x 80mm (10 x $3^1/_4$in)

decorative paper 250 x 350mm (10 x $14^1/_4$in)

greyboard,

scrap paper

sewing thread and needle

Here I show you how to make a bookblock with an **extent** of 160 pages. First I make the sections then I sew them together and finally I glue the spine and show you how to round the spine. When the bookblock is complete I then make a case and case-in the bookblock

Making the sections

Fold each of the forty sheets of paper down the middle, so that the shorter sides are together (**1**). Smooth down each fold with a bone folder. Now place four folded sheets inside one another to create a **section** (**2**). Do the same with the other sheets. Forty sheets will give you ten sections and each section contains sixteen pages. So with ten sections, your book will have an extent of 160 pages.

Now fold the two sheets of Ingres paper in half in a similar way. These will be the endpapers at the beginning and end of a book that form the visible connection between the bookblock and the case.

Endpapers can be white or coloured. Choose a colour that complements the covers.

Now lay a piece of scrap paper over the endpaper, 5mm ($^1/_4$in) in from the folded edge, and paste this strip. Do the same with the other endpaper.

Next, stick one of the glued endpapers on to the front of one section of paper – we call this the endpaper section. Be careful to line them up together properly, or the book will open badly later (**3**). Glue the other endpaper to another section in the same way.

Glue out a 30mm ($1^1/_4$in) wide strip of mull. Lay one of the endpaper sections on the glued piece of mull leaving a 5mm ($^1/_4$in) strip of mull showing beyond the folded edge (**4**). Fold this strip over and glue it to the last page of the section. Turn the endpaper section over and rub the mull down well on to the endpaper with your hand. Do the same with a second strip of mull and another section of paper.

2. *Now put four folded sheets of paper inside one another – this creates the first section.*

1. *Fold each of the forty sheets of paper down the middle and lay them on top of each other.*

3. *Glue the endpaper down the fold side in a narrow strip and stick it on to a section.*

Now leave the two endpaper sections to dry for a few minutes between two sheets of greyboard.

Professional bookbinders trim the bookblock with a special machine, but these are very expensive. If you have the chance to get your bookblock trimmed at a bookbinders or printers, or in a copy shop, you can skip the next part of the text (how to trim with a guillotine) and go straight to the instructions for sewing.

Here are some basic rules for trimming.

▶ The sections must have their sides exactly against the guillotine block.

▶ The left hand, (the one holding and pressing down the pressure bar of the guillotine), should exert more pressure than the right.

▶ As the upper blade of the guillotine is lowered, it should be pressed to the left against the fixed blade – this will ensure that the two edges line up precisely to produce a straight trim.

First, trim one of the short edges of the sections – the head or the tail (**5**). When trimming the opposite short edge, or the open long edge, place the sections up against both guillotine blocks (**6**).

The trimmed sections should measure 200 x 145 (8 x 6in).

The important parts of a guillotine are:
(a) the pressure bar, with which you press the paper you are going to cut firmly in place;
(b) the base with the scale on it; and
(c) the movable register, with which you set the precise measurements you want.

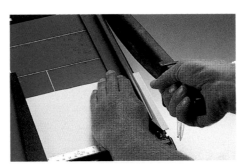

5. *First trim one of the short edges of the sections with the guillotine, then the one opposite.*

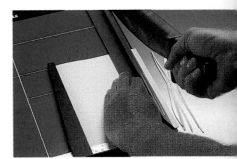

6. *Now trim the long edge of the section.*

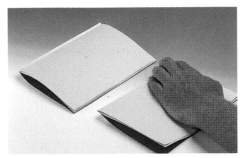

4. *Stick the endpaper section to the mull so that a strip of mull is visible beyond it, then fold this over.*

Sewing the bookblock

The sewn binding is a bookbinding technique with a long tradition. These days, it is mainly used for precious volumes, or for books that have to be particularly hard-wearing. On the spines of old leather-bound books you can often see the regular ridges formed by bundles of the hemp ties which were used for sewing. These days flat tapes are used instead of round twine.

On page 36 onwards I showed you how to sew an exercise book – a single-section binding. Now I am going to show you how to sew a book that has the binding strengthened by three tapes, positioned at intervals down the length of the spine. You can make the strips from a piece of calico.

Draw the position of the tapes on the blocks of all the sections (**7**), as shown in diagram A.

Glue the first 25mm (1in) of all three tapes on one side and stick them to one of the endpaper sections (**8**).

Next, cut a piece of thread about 1.5m (5ft) long and thread the needle with it. Open the endpaper section in the middle and align all the folded sheets of paper.

Now for a few basic rules – see page 36 for a fuller description:

▶ Always pre-punch holes for the needle from the inside out.

▶ Hold the needle at an angle of 45° to the fold in the paper.

▶ Always pull the thread parallel to the fold.

Now lay the first section (with its endpaper face down) on the table with the fold up against the edge of the table. Hold it firmly with one hand and then bore eight holes with an awl: the first 5mm (1/4in) from the tail, one on either side of each tape, then another 5mm (1/4in) from the head.

Starting from the outside, draw the thread through the hole at the tail, then out through the hole to the right of the first tape, around the tape, and back in through the next hole (**9**).

Diagram A. Position the tapes on the end paper section.

40mm
(1⁵/₈in)

40mm
(1⁵/₈in)

40mm
(1⁵/₈in))

50mm
(2¹/₈in)

7. *Draw the positions of the tapes on to the sections as shown in diagram A.*

8. *Line the three tapes up with the edge of the mull strip and glue them down.*

9. *Sew through the first hole from the outside in, then through the second from the inside out, and sew around the tape from the outside in.*

Sew in the second (**10**) and third (**11**) tapes in the same way, with the thread always running between tapes on the inside of the sections. Pull the thread out of the last hole until the other end is hanging only about 30mm (1¼in) out of the first hole. If you want to trim the bookblock after you have stitched the sections, pierce the first and last holes a little further in from the edges so that the thread does not get cut off too.

Now rub the fold of the section again with the bone folder, between the tapes, to sharpen it.

Open up the second section, place it on the sewn endpaper section, and sew it in the same way, but in the opposite direction. When you get to the end of the second section, pull the thread tight again and rub the section fold between the tapes with the bone folder. Knot the ends of the thread together firmly (**12**).

Be careful not to pierce the tapes with the needle when you are sewing.

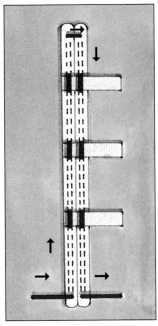

Diagram B. This diagram shows how the thread runs when sewing the first and second sections.

11. *Sew around the third tape as well. Then bring the thread through the last hole from the inside.*

12. *Sew the second section just as you did the first, but this time in the opposite direction.*

10. *Take the thread around the second tape.*

Once you have passed the thread through the last hole of the third section, fasten it to the second section as shown in diagram C, forming a loop around the thread which joins the first and second sections. Pull the thread tight, then sew and fasten the fourth section to the third in a similar way, but making the joining loop at the other end of the spine (**13**).

Carry on like this until you have sewn all the sections. The last section is the second endpaper section, and you should attach this so the endpaper is on top (**14**).

Do not forget to sharpen all the folded edges of the sections after each stage of sewing, using the bone folder. Pull the sewing tapes taut from time to time, too. If you run out of thread, join another length on to the first with a small knot. This knot should always lie on the outside of the sections, above a tape.

Finally, take the thread under the last section more than once, loop it round itself and cut off the end, leaving about 5mm ($^1/_4$in).

Now pull the tapes tight and glue them to the endpaper section (**15**) after cutting them off flush with the edge of the glued-down strip of mull.

Gluing the endpaper sections

Lay the bookblock on the table with its spine level with the edge, open it up and let the first endpaper section hang over the edge of the table (**16**). Cover the top page of the second section (page 17) with a piece of white scrap paper, so that only a 5mm ($^1/_4$in) strip of paper is exposed. Carefully brush adhesive along this strip.

Remove the scrap paper and close the book. Make sure that the endpaper section lines up with the others.

Turn the book over and glue the second endpaper section to the last-but-one section in the same way.

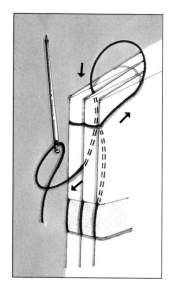

Diagram C. This shows the path taken by the thread when sewing the third section to the second.

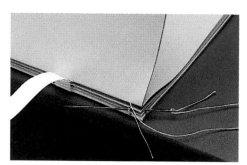

13. Sew the fourth section to the third in the same way, but start at the opposite end.

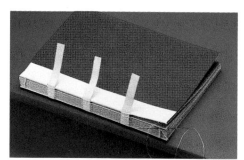

14. Sew the second endpaper section to the last of the ten sections.

Gluing the spine

Paste the spine with adhesive, brushing towards the outer edges so you do not get any glue on the trimmed pages. Rub the glue between the sections with your finger (**17**). Knock up the three trimmed sides of the bookblock one last time – when the adhesive has dried you will not be able to move it any more!

Now place the bookblock between two pressing boards so that the glued spine protrudes about 5mm ($^1/_4$in) and leave it to dry for about an hour.

> *Books that are going to be trimmed with a cutting machine must be trimmed at the fore-edge before they have their spines rounded.*

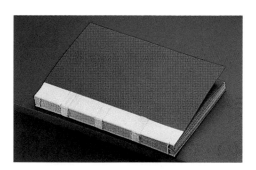

15. *Trim the tapes flush with the edge of the strip of mull and glue them down.*

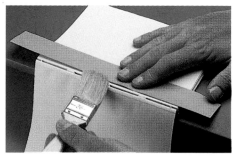

16. *Let the top endpaper section hang down over the edge of the table and glue a narrow strip of the section.*

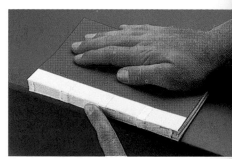

17. *Brush adhesive on to the spine of the bookblock and rub it in with your finger.*

Rounding the spine

Most books you can buy these days have flat spines. If you would like to round the spine – which looks a lot better – this is how you do it.

Hold the bookblock firmly with one hand, with your fingers on the endpaper and your thumb on the fore-edge. Now, using a rubber or wooden hammer, hammer the long side of the spine several times, quite hard and at regular intervals (**18**). This action pushes the uppermost sections forward. Your fingers assist this process by pulling the bookblock forward while your thumb opposes it.

Turn the bookblock over and do the same with the other long side of the spine. Turn the bookblock over again and hammer it again, but not so hard this time.

Press the bookblock between two boards with G-clamps, allowing the spine to protrude about 5mm ($^1/_4$in) again. Brush more glue on to the spine and stick some thin mull over the glue. Cut the mull beforehand so that it covers the whole width of the spine. The length should be sufficient to allow the fabric to reach the two outer stitches (**19**). Brush the fabric into the spine, then apply more adhesive, so that the weave of the fabric is completely saturated. Next, press the bookblock for about twelve hours.

Adding a head band

A head band is purely decorative, but it does make the book look more professional. Glue the upper and lower edges of the spine and place the ribbon flush with the edge (cut it if need be). The coloured knobbles of the ribbon rest on the trimmed edge, while the rest is firmly glued to the spine (**20**).

18. *Round the spine with a hammer.*

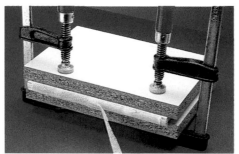

19. *Glue a piece of mull all over the spine as far as the outer stitches.*

20. *Glue the head band to the head and tail of the spine.*

Making the case

After you have finished the bookblock, you must make the case. Diagram D shows you a cross-section of an open case (the inside is at the left) made of two pieces of cover board, two pieces of decorative paper, a spine insert, a piece of bookcloth and a paper lining strip.

Sizing the materials

To make a case, you will need to base your measurements on those of the bookblock (see Diagram D).

▶ First measurement: the height of the bookblock (here it is 200mm (8in)).

▶ Second measurement: the width of the bookblock (145mm (6in)).

▶ Third measurement: the width of the spine, which corresponds to the thickness of the bookblock with a straight spine (this measurement depends on the type of paper you have used). If you have made a rounded spine, you will have to measure it by rolling your ruler round the curve of the spine.

Make a note of these measurements . They are important for cutting out the cover boards, spine insert and paper lining strip.

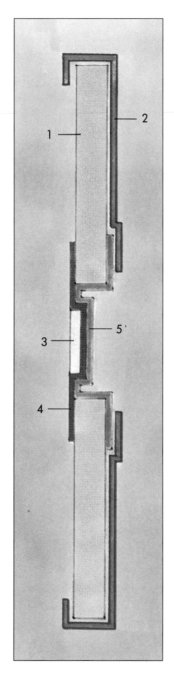

Diagram D
1. *Cover board*
2. *Decorative paper*
3. *Spine insert*
4. *Paper lining strip*
5. *Bookcloth*

The cover boards, which are made of millboard, will protrude 3mm (1/$_8$in) beyond the head and tail of the bookblock, so cut them 6mm (1/$_4$in) longer in all. The width of the cover boards should be the same as that of the bookblock: 145mm (6in).

The spine insert is made of card and is the same length as the cover boards (in this case 206mm (8^1/$_4$in)) and the same width as the spine (third measurement).

The lining strip is made of kraft paper and is the same length as the cover boards (in this case 206mm (8^1/$_4$in)) but about 60mm (2^3/$_8$in) wider than the spine insert (70–75mm (2^3/$_4$– 3in)).

To make the case you will need:

cover boards – two pieces of millboard, 206 x 145mm (8^1/$_4$ x 6in)

spine insert – a piece of card 206mm (8^1/$_4$in) the width of the spine

lining paper – a strip of kraft paper 206 x 75mm (8^1/$_4$ x 3in).

Assembling the case

On the card for the spine insert, and on the lining strip made of kraft paper, mark the centre of the head and tail. Glue the piece of card all over on one side and let the glue sink in for a few minutes. Now lay the card on the brown paper so that the marks line up with each other (**1**).

Turn the paper over and run over the edges of the card beneath with the bone folder. Now draw a line 6mm ($^1/_4$ in) from each of the two edges (**2**). Place a piece of scrap paper against the right-hand pencil line and glue the brown paper that is left exposed. Stick a cover board to the glued area, lining it up carefully with the edges of the paper and the pencil line (**3**). Do the same on the left-hand side.

1. *Glue the strip of card in the middle of the piece of brown paper so that the pencil marks line up.*

2. *Draw a pencil line on the kraft paper, 6mm ($^1/_4$in) either side of the card.*

3. *With the aid of a piece of scrap paper, glue the right-hand side of the kraft paper and stick the first cover board to it.*

Check with a straight-edge that the cover boards line up properly at the head and tail (**4**).

Finally, rub down all glued areas carefully with the bone folder.

Decorating the case

To create a quarter-cloth binding, stick decorative paper and bookcloth to the basic case as shown below.

First, glue the back of bookcloth all over. Place the case, with the spine insert uppermost and the cover boards folded up (as shown in figure **5**), in the centre of the bookcloth.

Turn the case over and rub the cloth down well with the bone folder along both edges. Then fold the flaps of cloth on to the cover boards and rub them down well. Turn the case over once again and turn in the cloth at the head and tail. Burnish all the glued areas with the bone folder, paying particular attention to the edges and the spine insert (**6**).

The corners are the most vulnerable parts of a book. For protection, you can reinforce them with small pieces of bookcloth – this is then termed a half-cloth binding. Cut four strips of bookcloth 25 x 60mm (1 x 2$^{1}/_{4}$in). Stick one piece on each outer corner, at an angle of 45°, so that one side extends beyond the corner by about 3mm ($^{1}/_{8}$in). Now fold the flaps in, first on one side and then on the other, tucking in any excess at the corner.

4. *Glue the second cover board in the same way, then check that the boards are aligned properly using a steel rule.*

5. *Stick the case to the bookcloth with the spine insert uppermost and the cover boards held as shown here.*

6. *Go over all the edges of the spine insert with the bone folder.*

Decide how much of the bookcloth you want to remain visible and then draw a pencil line down each side of the bookcloth. In this case I chose to have 20mm (³/₄in) of cloth showing.

Now glue one of the pieces of decorative paper all over, on the reverse side, and let the glue sink in for a few minutes. Place the paper on one of the cover boards so that the pencil line is just covered up and the upper and lower edges of the paper protrude 15mm (⁵/₈in) (**7**). Lay a piece of paper over the cover paper to protect it, and burnish the whole thing with a bone folder, paying especial attention to the edge which is glued over the bookcloth.

Finally, turn the case over and cut off both corners of the paper on the diagonal, about 3mm (³/₈in) from the corners – a little more than the thickness of the millboard you have used (**8**).

If you have reinforced the corners with bookcloth, you should cut the corners of the paper diagonally so that it just over-laps the bookcloth.

Now, turn in the short sides of the paper, pinch in the corners, then turn in the long side (**9**). Do the same with the other cover board – you have now finished making the case.

7. *Glue the cover paper so that it just covers the pencil line on the bookcloth.*

8. *Cut off the corners of the paper diagonally about 3mm (¹/₈in) from the corners of the board.*

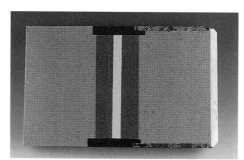

9. *First turn in the short sides, then the long one.*

70

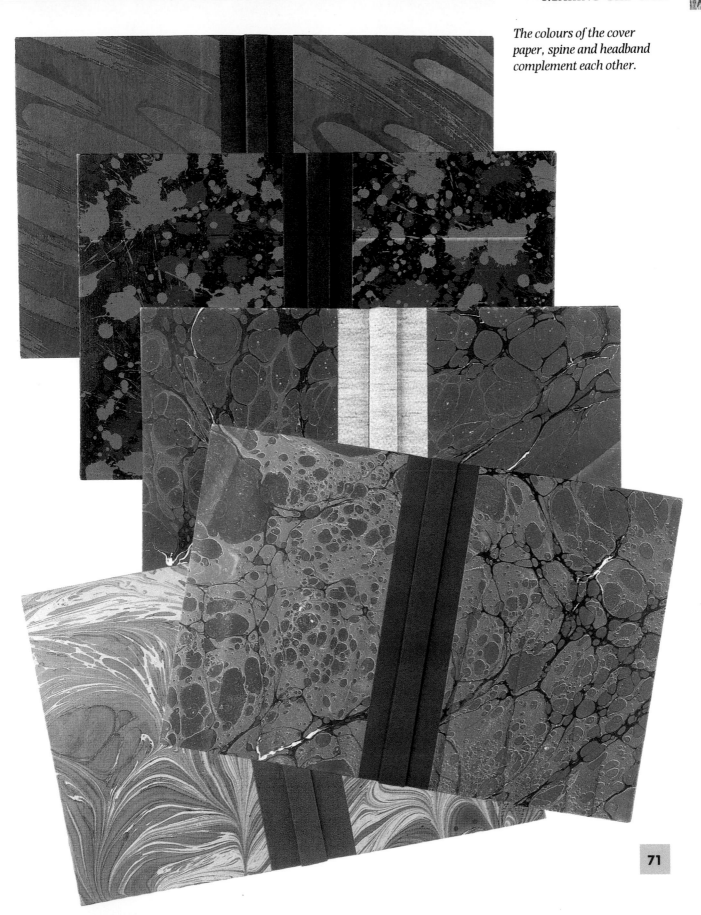

The colours of the cover paper, spine and headband complement each other.

If you have rounded the bookblock, you should also round the spine. To do this, place it on the table, holding one of the boards and the spine clear of the table. Then rub the spine evenly with a bone folder (*10*) to give it the same degree of roundness as the bookblock.

10. Round the spine of the case with the bone folder so that it will lie snugly round the spine of the bookblock.

11. Glue the endpaper and the mull of the first section, starting in the centre and working outwards.

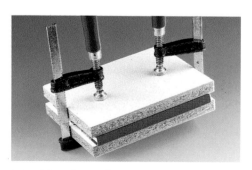

12. After gluing the two endpapers, press the book tightly between G-clamps.

13. Insert a piece of silicone-release paper inside the covers at each end of the book and press the book again.

14. If any pages of the book have got stuck together, free them carefully with the bone folder.

Casing-in

Slip the bookblock into the case and check that it has an equal border at the head tail and fore-edge when it is pressed against the spine.

Hold the bookblock in place and open up one of the cover boards.

Brush adhesive all over the exposed endpaper and mull, working from the middle outwards **(11)**. Try to avoid getting adhesive on the trimmed edges of the bookblock.

Bring the cover back and press it firmly down on to the bookblock.

Carefully turn the whole book over and fix the other cover board to the second endpaper.

Place the book between two pressing boards, the edges of which must align with the spine edges of the cover boards, apply pressure evenly with a pair of G-clamps and then release the pressure immediately **(12)**. Remove any excess adhesive with a cloth.

Now, place a sheet of silicone-release paper between the endpapers at the front and back of the book, replace the pressing boards and G-clamps and leave for at least eight hours **(13)**.

If any of the pages do get stuck together, use a bone folder to pry them apart **(14)**.

> *You have now finished your first book! From now on you will get better at it – and quicker – and you will soon have a whole stack of books.*

'Perfect binding' single sheets

What if you want to bind single sheets of paper which cannot be folded to allow for sewing? Bookbinders searched for a suitable method for years, but it has only really been possible since the development of modern glues with their exceptionally good adhesive qualities. By fanning out the pages while gluing, you can make sure that the glue gets between all the pages and fixes them firmly in position. Make sure you use the right kind of glue, though!

If the sheets of paper you want to bind are not all the same size, trim them using a guillotine (see page 61) to the size you want. Cut two folded endpapers to the same size and then place one on top of the block of paper and one underneath, with the fold on the left-hand side in each case.

Now cut two pieces of mull, each 10mm (³/₈in) shorter than the spine length and 60mm (2in) wider than its width.

Knock the block into shape and then clamp it between two narrow pressing boards so that the spine protrudes by about 100mm (4in).

Next, push the spine of the block to one side (to create small steps between each page) and apply a generous amount of adhesive **(1)**. Push the block in the opposite direction and apply more adhesive.

Press the bookblock together along its whole length with your thumb and index finger. Now glue the first strip of mull to the spine, pulling it taut with your thumb and index finger while your other fingers press the bookblock

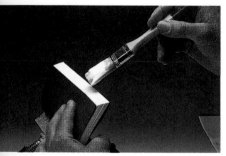

1. Push the pages to one side and brush glue on to them. Then push them in the other direction and glue them again.

2. Apply the first strip of mull to the glue on the spine and pull it taut with your thumb and index finger.

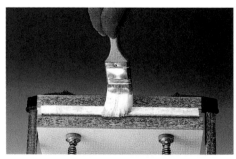

3. After applying the second piece of mull, allow the bookblock to dry, press it, and glue the spine.

together (**2**). Brush in the glue so that the weave of the mull is completely embedded in it. Apply a second piece of mull in the same way.

Open the G-clamps and lay the bookblock between two boards so that the spine now only protrudes slightly from them and reclamp. Allow the bookblock to dry for about half an hour.

Adjust the pressing boards again so that the spine is protruding by about

5mm (¼in). Glue the spine again (**3**), keeping the glue away from the trimmed edges.

Now glue a third (narrow) piece of mull to the spine of the bookblock (**4**). Leave it to dry for twelve hours.

Take it out of the press and trim the flaps of mull to 20mm (¾in) wide, using a cutting mat and straight-edge (**5**).

You can now make a cover and complete the book as shown earlier.

If you only want a simple binding for single sheets, you can leave out the endpapers, second pressing and the third strip of mull. Leave it to dry for twelve hours and you will have a somewhat unrefined but still tough book.

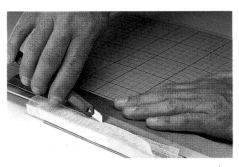

5. *Trim the flaps of the mull on the front and back, using a cutting mat and a steel straight-edge*

The 'perfect binding' is finished and you can now add the case.

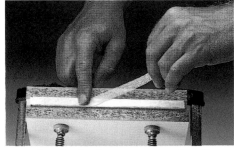

4. *Glue the third narrow strip of mull on top of the other two and leave the bookblock to dry for twelve hours.*

Full-cloth binding

With quarter- and half-cloth binding, the case is covered partly with cloth and partly with paper; with a full-cloth binding the case is entirely covered with cloth. Here I show you how to cover the case: all the other steps for casing-in are as shown on pages 72–73. Measure the height and the width of the assembled case, add 30mm (1¼in) to each measurement and cut your cloth to this size. Remember to keep the warp threads of the cloth parallel to the spine.

Glue the cloth all over on one side and lay one of the cover boards on it as shown in (**1**) below. Do not let the other parts of the case – spine insert, strips and the other cover board – touch the glue. There should be 15mm (⅝in) of glued cloth visible round each edge.

Now turn the case over and put a weight on the glued side. Hold the remaining piece of sticky cloth up with one hand while you rub the bone folder along the edges of the cover board(**2**). Gradually lower the cloth, pressing it into the crease at one side of the spine insert, across the spine insert, into the second crease and finally rub the cloth down over the second cover board.

Now clean up your table and place the case on it, cloth side down. Glue the turn-ins again if they have dried out. Cut off all four corners of the cloth off diagonally at a distance of 3mm (⅛in) from the corners of the cover boards.

Turn in the long sides of the cloth, pinch in the corners and then turn the short sides in (**3**).

After you have rubbed down all the edges, grooves, turn-ins and all the other surfaces once again with the bone folder, leave the case between two weighted sheets of greyboard for several hours before gluing it to the bookblock.

Full cloth-bound book.

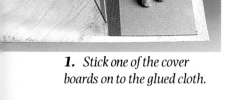

1. *Stick one of the cover boards on to the glued cloth.*

2. *Turn the case over and rub the cloth into the spine with the bone folder.*

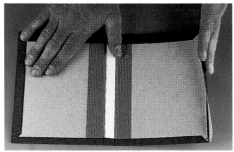

3. *Turn the case over again, cut off the corners of the cloth, turn in the excess and glue it down.*

Full binding with paper

The finished effect of this type of binding is similar to that of a full-cloth binding in that the paper wraps around the spine on to the two cover boards. However, for strength reasons, you must use three pieces of paper rather than one piece.

To get the wrap-around effect you must cut the pieces from one sheet of paper. You must, therefore, measure and mark the dimensions carefully.

Measure the cover boards and add 15mm ($^5/_8$in) to the width and 30mm ($1^1/_4$in) to the height.

Measure the width of the spine, double it and then add 6mm ($^1/_4$in).

Draw these measurements on the back of a sheet of decorative paper as shown (**1**), and then cut them out (**2**).

Stick the pieces of paper on to the cover in much the same way as you did the quarter-cloth binding (pages 69 – 72) but glue the cover board pieces close to the spine creases (**3**).

Full binding with paper.

1. *Mark out the shapes of all the pieces on the back of the decorative paper.*

2. *Cut out the three pieces of decorative paper.*

3. *Cover the case in a similar way to that for a quarter-cloth binding.*

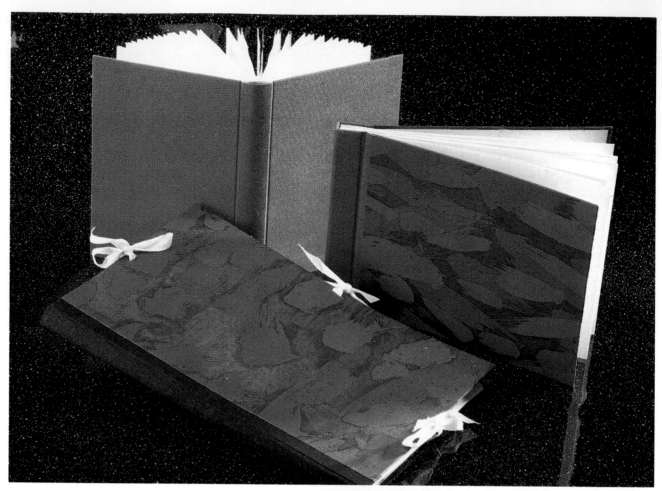

A good idea for a present would be a matching set of items, such as a book, a portfolio and a photograph album. They could be covered in the same design or in different but complementary ones.

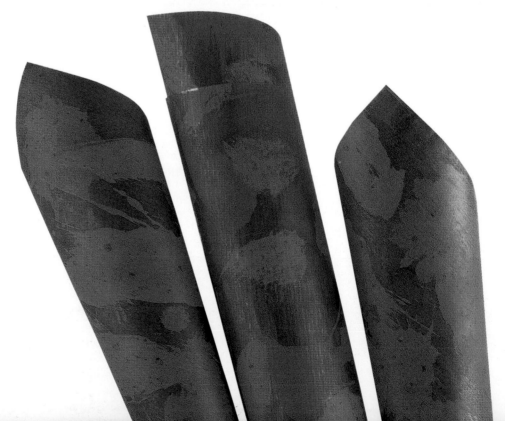

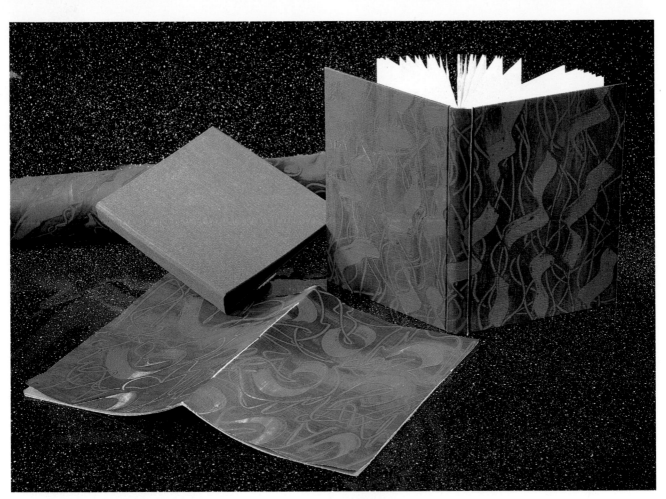

This collection consists of a notebook, a full-cloth-bound book and a paper-bound book, all in shades of blue. The covers are made with hand-made batik paper.

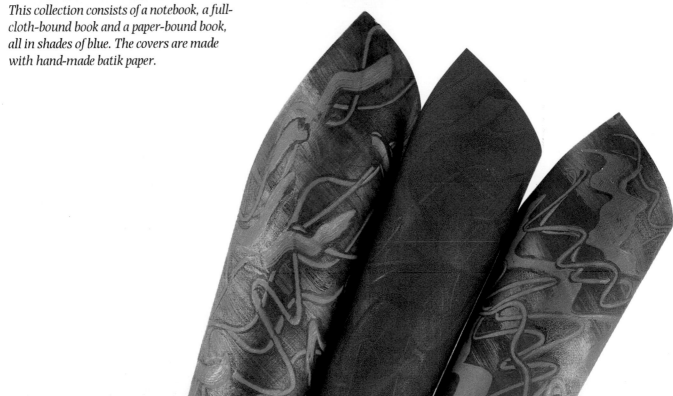

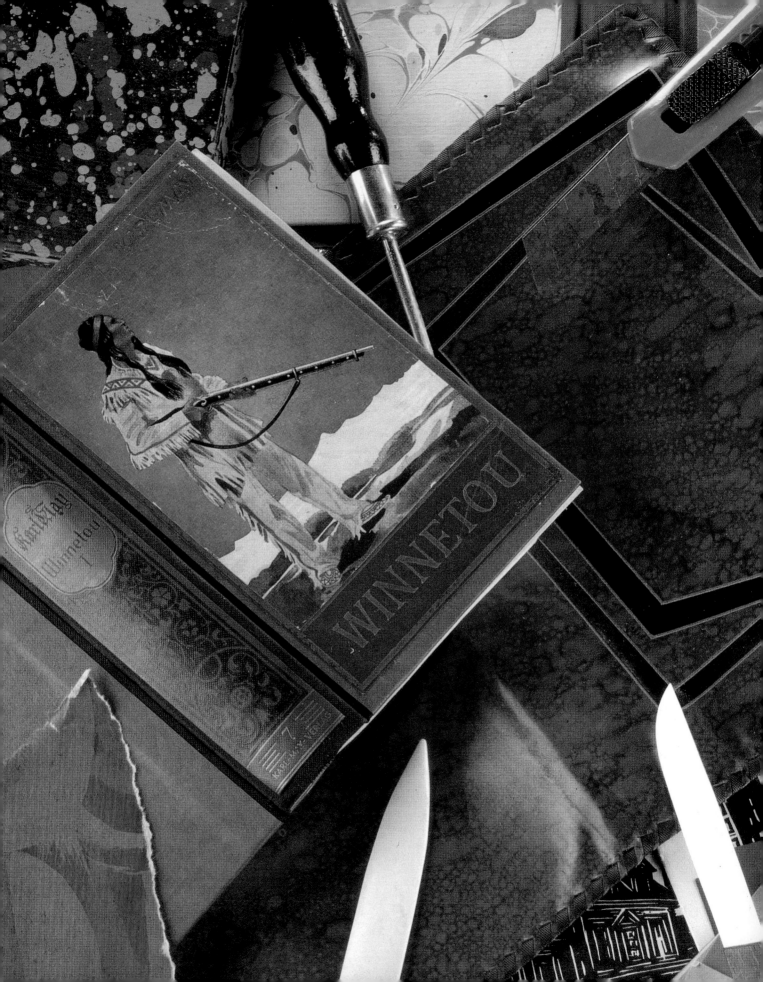

Repairing your own books

In the previous chapters I have shown you how to make a new book – in this one you will learn how to repair damaged books: their covers, pages, bookblocks and bindings.

Before: the page is badly torn.

1. Lay the edges of the tear precisely in place.

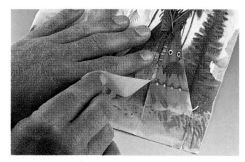

2. Stick a strip of archival tape over the tear, front and back.

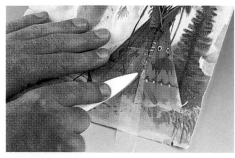

3. Rub the strips down well with the bone folder on both sides of the paper.

After: you cannot see the join after this page was repaired with special archival tape.

Pages and corners

Now for ways of repairing various forms of damage, from loose pages to restoring bindings. Many of these problems are caused by shoddy materials or bad workmanship – but sometimes the reader is the guilty party.

Study your damaged book carefully – if it is very valuable, it may be better to hand it over to a professional bookbinder.

Gluing in loose pages

If a page has come out of your book, first trim it a little on the left-hand side. Then glue a 2mm ($1/16$in) wide strip, using a piece of scrap paper to keep the rest of the book clean, and stick it back in the book. Push it right back into the spine to stop it poking out at the fore-edge.

Repairing tears in paper

Torn pages can be repaired quite easily using either a special archival adhesive tape or, if you are a purist, with paste and Japanese tissue.

Never try using normal clear adhesive tape – this soon goes yellow, the adhesive dries out, the tape comes off and leaves ugly residues of adhesive that are really hard to remove.

The special tape is available in different widths (I would recommend using 20mm ($3/4$in) wide tape), it retains its adhesive properties for a very long time, it does not discolour and is practically invisible.

Japanese tissue is very strong, even when wet, and can be applied to a tear with wallpaper paste which is transparent when dry.

Carefully hold the edges of the tear precisely in place (**1**) then stick two pieces of tape or tissue over the tear on the front and the back (**2**). If using tape, rub the strips down well with the bone folder (**3**). If using Japanese tissue, you will need to sandwich the repaired sheet between two sheets of silicone-release paper and dry it under weights.

Repairing corners

The corner of a case is the most easily damaged part of a book. Over the years the cover paper can rub off and the exposed cover board can then disintegrate into layers (**4**).

To repair the corner, put some glue on your finger and apply it between the board and the paper or cloth (**5**). Then press them together with your finger or the bone folder. When the glue has dried, the corner will be fine.

4. The corner of this book is badly damaged and the cardboard is clearly visible.

Afterwards – the corner is nearly as good as new.

5. Apply some glue between the cover board and the paper or bookcloth with your finger.

This bookblock has got damaged over the years and needs binding again. The illustration (far right) shows the book after the repair process.

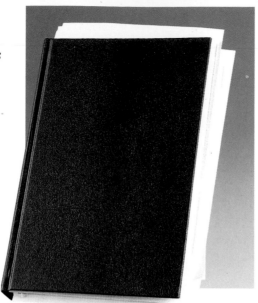

Repairing a perfect-bound book

The cover of this book is all right, but the pages are coming out. It needs a new binding.

Separating the bookblock and the case

Cut right through the glued-on endpapers with a craft knife, about 20mm (³/₄in) from the central fold (**1**). Only press lightly on the blade, though, so that you do not cut the cover boards too. Now hold the bookblock with one hand and press the case downwards with the other hand (**2**). The bookblock will break away from the case along the line of the cut. Do the same thing with the other endpaper.

Strengthening the case

Cut a strip of mull a little shorter than the height of the bookblock and about 50mm (2in) wider than the spine insert. Glue it on the inside of the cover spine (**3**). Rub down the mull and the reverse side of the spine with the bone folder.

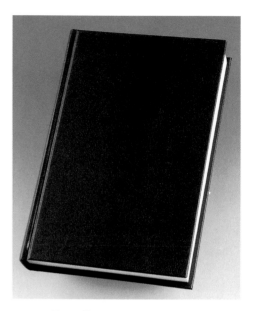

New binding

Carefully tear apart any pages which are still glued together (**4**) and put them one on top of the other in their correct order (**5**). Remove any remnants of glue from the spine of the bookblock with a knife and repair any tears in the pages (see pages 82–83). Replace the old endpapers with new ones (**6**) cut to fit – one on top of the bookblock and one underneath it. Glue the pages as shown on page 74 onwards. Then glue the restored bookblock to the case.

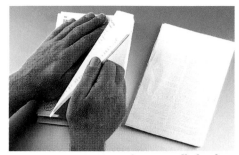

4. *Separate any pages that are still glued together.*

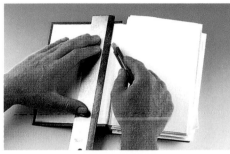

1. *Cut the endpapers with a craft knife.*

5. *Put the pages in the right order again.*

The fewer traces of your work there are, the better the repair work! Here is a crafty idea – soak your new endpapers in black tea or coffee for a few minutes before you glue them in and they will look the same age as all the other pages in the book. If you dry paper between two sheets of greyboard, it will go slightly yellow. This makes it ideal for replacing damaged pages of an old book.

2. *Tear the bookblock from the case along the line of the cuts.*

6. *Make new endpapers and glue these in place.*

3. *Glue a strip of mull to the inside of the case.*

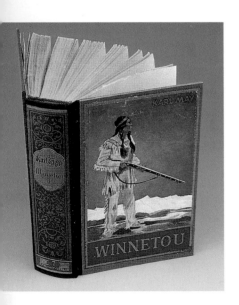

Before: the covers of this book have been torn off.

After: the restored book in all its glory.

Restoring covers and bindings

This book is in a sorry state! The fabric is hanging off and the covers have become detached. The binding has been loosened but the pages are still holding together thanks to the stitched binding.

Renewing the covers

Using a craft knife, carefully cut round the front cover illustration and the spine design (**1**), then carefully peel them off the cover board and spine (**2**).

If the cover is bound with paper or very thin cloth, this will not be suitable because the material may tear. Instead, remove the complete cover from the bookblock and soak it in a bowl of warm water. The glue will soon dissolve and then you can easily remove the cloth or peel the paper away from the cardboard.

Make a new cover (see page 67 onwards) using a cloth or paper that is close in colour to the original.

Renewing stitched binding

The spine of a bookblock may be covered with mull, calico or paper. Dampen this glued-on layer several times with a wet sponge and then carefully scrape off the layer with a kitchen knife to remove the old glue and expose the sewn binding.

1. *Cut round the parts of the cover illustration that you want to retain.*

2. *Carefully peel the illustrations from the cover board and spine.*

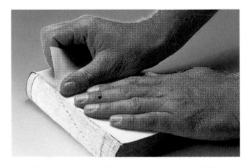

3. *Glue on the endpapers, each glued along one edge.*

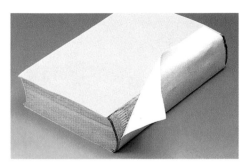

4. *Glue a strip of mull to the spine.*

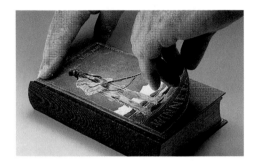

5. *Glue the cover illustrations to the covers.*

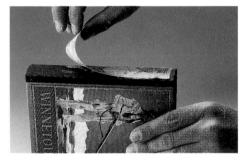

6. *Glue the old spine to the new one.*

Cut two folded endpapers to fit the size of the bookblock. After gluing their edges with the aid of a piece of scrap paper, stick one of the endpapers to the first page of the bookblock (**3**) and the other to the last page.

After that, glue the spine as shown on page 65 and, if the original bookblock had a rounded spine, round it again using a wooden hammer.

Stick a strip of mull to the spine of the bookblock to strengthen the endpapers and stabilise the spine (**4**). The strip should be 25mm (1in) wider than the spine on each side but fall just short of the head and tail of the book.

If the book had head bands, glue them in, or get new ones if need be (see page 66).

After you have glued the case to the bookblock (see page 72 onwards) and let it dry, take it out of the press, glue the pieces of the original front cover on to the new one (**5**). Place the book between two sheets of greyboard and then between two pressing boards and tighten the G-clamps (see page 66). Open the press again immediately and glue the old spine cloth with the title on it to the new spine (**6**). Place a piece of scrap paper over the spine to protect the surface and rub down with the bone folder. After an hour's drying time the book is finished and looks superb.

This book, too, needs its covers and binding restoring.

Repairing sections

The binding of this book has loosened so much that the stitching on the bookblock needs replacing.

Removing sections

Cut the bookblock out of the case as described on page 86 and remove the endpapers. Next, cut the stitches of the first section with a bookbinders' knife (**1**). Open the last page of the first section, take the section in one hand, hold the bookblock in the other, and carefully detach the section (**2**). The section should not be damaged by doing this – we are just breaking the glued strip between sections. Scrape off any remnants of glue with a kitchen knife. Do the same to all the other sections (**3**).

Repairing sections

When you are taking out sections, you may possibly damage a page and need to repair it.

If there is a tear in the paper, repair it with special paper (see page 82). If the paper is torn at the fold, glue a small strip along the left-hand side and stick it back into the section.

If a lot of pages are torn, trim them a little with the guillotine, either singly or as a section (see page 61). This will give you single sheets instead of a section, which you can then bind using glue (see page 74 onwards). When you have repaired your sections, bind them again from scratch.

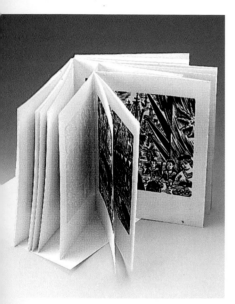

Before: the binding of the sections has loosened.

1. *Cut the stitches of the first section with a knife.*

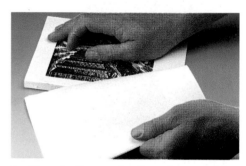

2. *Tear the first section from the rest of the bookblock like this.*

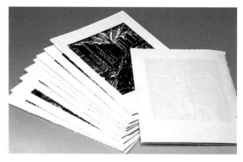

3. *Do the same with all the rest of the sections and rebind them.*

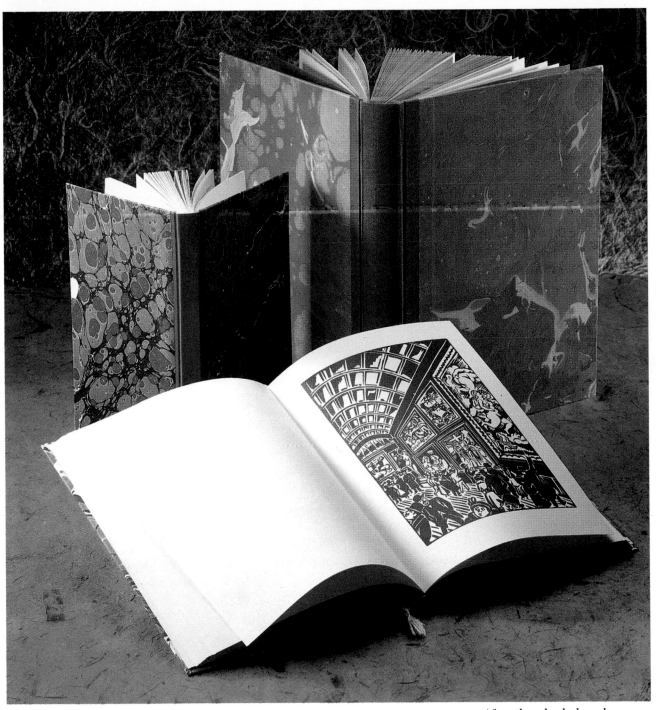

*After: these books have been
resewn and look as good as new.*

Decorative labels

The labels on these pages will be really useful for sticking on the front of your books, albums and portfolios. You can write what you like on them.

Photocopy them the size you want – enlarged or reduced – on white or coloured paper and cut round the outer edge.

Glossary

Bookblock – the paper contents of the book, as distinct from the outside cover.

Casing-in – the process of attaching the bookblock to the case.

Endpapers – the first and last leaves of the bookblock, often made from coloured or patterned paper.

Fore-edge – the front edge of the book, so called because in early times books were placed on shelves with the spine innermost.

Full binding – a binding where the entire case is covered with a single material, normally a cloth.

Grain direction – nearly all materials are made from fibres which lie in predominantly one direction.

Greyboard (pulpboard) – available from bookbinding suppliers and art and craft shops. Greyboard is made from waste fibre and is less dense than millboard. There is a range of thicknesses, which can be cut with a knife.

Guards – strips of paper that are incorporated into the bookblock to create extra swell at the spine. They are used to compensate for the later addition of photographs, as in an album.

Half binding – a binding where the spine and fore-edge corners (or the complete fore-edge) are covered with one material and the rest of the boards with another.

Head – the top edge of the book.

Head band – a ribbon used to decorate the head and tail of a spine.

Leaf – a single sheet of paper in a book (two pages). A sheet folded in half will have two leaves and hence four pages.

Millboard – only available from bookbinding suppliers. This is the best-quality bookbinding board and comes in a range of thicknesses. It is a dense fibre-board and the thicker sheets are quite difficult to cut without special board-cutting equipment. However, boards up to 2mm ($^{1}/_{16}$in) in thickness can be cut with a sharp craft knife and straight-edge.

Page - one side of a leaf.

Perfect binding – a method of binding single leaves together using only glue.

PVA (polyvinyl acetate) – sometimes known in the trade as 'white glue', a flexible quick-drying adhesive.

Quarter binding – a binding where the spine of the book is covered with one material and the covers with another.

Sections – a set of folded sheets of paper as prepared for sewing.

Silicone-release paper – a paper treated with silicone to which adhesive will not adhere.

Single-section binding – a book made from only one set of folded pages; limited to very small books.

Spine – the back edge of the book (the part visible when a book is placed on a shelf).

Tail - the bottom edge of a book.

Tipping-in/on – a commonly used term to describe the attachment of paper or other materials to another surface by means of a narrow strip of adhesive (usually about 5mm ($^{1}/_{4}$in) wide).

Index

Three-dimensional Découpage
Vivien Crook

Découpage means cutting out – and three-dimensional découpage is the fascinating craft of cutting out and layering multiple copies of the same image to make a picture with a 3-D effect.

Pictures can be as simple or as intricate as you like: choose a single flower or a whole street scene. Vivien Crook shows you, step by step and layer by layer, how to use a range of source materials – coloured paper, colour photocopies, rubber stamps, cards, wrapping paper and commercial sets of prints – to create stunning 3-D pictures.

Paper into Pots and Other Fun Objects:
using hand-made recycled paper and papier-mâché techniques
Gerry Copp

Gerry Copp makes hand-made paper from coloured waste paper such as junk mail to decorate her stunning papier-mâché ware. She demonstrates the many and varied techniques you can choose from to make a range of colourful items, from bowls and plates to clocks, boxes and jewellery. Her ideas include collaging torn shapes and coloured foil, and using waxed and herb papers.

Polly Pinder's Papercrafts
Polly Pinder

Polly Pinder cleverly shows you how to make an amazing range of creative items, from paper dressing-dolls and working windmills to greetings cards and elegant candle-shades. Her clear step-by-step instructions, drawings and trace-off outlines are complemented by colour photographs of the finished models.

The Craft of Natural Dyeing
Jenny Dean

This excellent guide offers the craftsperson a successful alternative to synthetic dyes. It shows the possibilities of discovering new sources of colour and the satisfaction of growing, or gathering, dyestuffs and then using them to produce good fast colours.

Scented Herb Papers
Polly Pinder

Capture the essence of the garden – its scent and colour – in hand-made paper. Try embedding garden herbs such as sage, mint or sweet cicely in your paper, or roses and lavender, cinnamon, and orange rind; emboss it with leaves or scent it with essential oils. Experiment with this inexpensive and rewarding craft to create a stunning range of delightfully scented papers and finished items such as writing paper and envelopes, bookmarks, lamp-shades, book covers, candle-shades, place settings, paper roses, earrings, covered boxes and drawer liners.

Marbling on Paper using Oil Paints
Anne Chambers

The magical and mysterious process of marbling goes back as far as the twelfth century in Japan. It is still popular today, and Anne Chambers' book shows how to create unusual and original papers. There are step-by-step photographs and clear instructions for the technique, followed by illustrations for effects such as marble cut, patterned, and combed.

Hand-Made Books
Rob Shepherd

With over 100 practical colour photographs, plus a multitude of ideas for using fabrics and papers as covering materials, this book will enable even the first-time bookbinder to achieve satisfying and successful results.

Creative Handmade Paper
David Watson

David Watson develops the 'recycling paper' theme in this delightful book. Using household equipment, he shows the simple task of making recycled paper, not only from waste paper but also from plants, leaves, straw and other organic materials found in the home and garden. He gives advice on dyeing and scenting, plus embossing and water-marking; and finally there is a section on sculptured pictures and collages made from paper pulp.

If you are interested in any of the above books or any of the art and craft books published by Search Press, please send for a free catalogue to:

Search Press Ltd.,
Department B,
Wellwood, North Farm Road,
Tunbridge Wells, Kent TN2 3DR
Tel. (01892) 510850 Fax (01892) 515903

or (if resident in the USA) to:
Arthur Schwartz & Co., Inc,
234, Meads Mountain Road, Woodstock, NY 12498
Tel: (914) 679 4024 Fax: (914) 4093
Orders, toll-free: 800 669 9080